THE STORY OF
ST. FRANCIS OF ASSISI

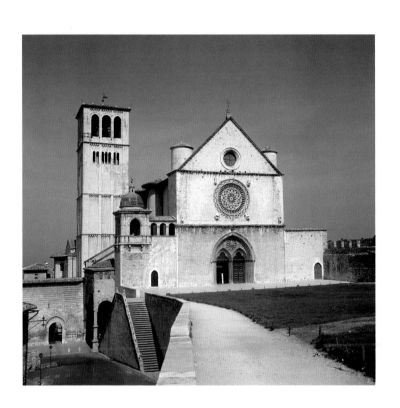

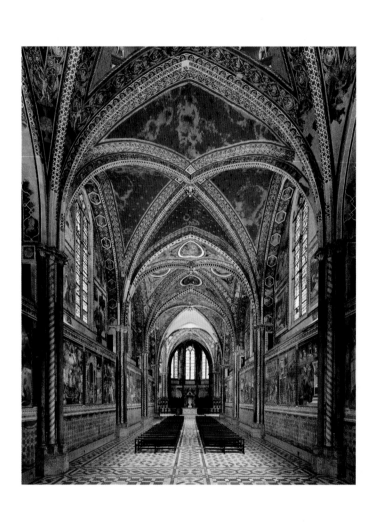

Timothy Verdon

THE STORY
of
ST. FRANCIS OF ASSISI

IN TWENTY-EIGHT SCENES

UTET
GRANDI OPERE
TORINO, ITALY

mount
tabor
BOOKS

PARACLETE PRESS
BREWSTER, MASSACHUSETTS
BARGA, ITALY

2019 First Printing This Edition
2015 First Printing

The Story of St. Francis of Assisi: In Twenty-Eight Scenes

Italian Text Copyright © 2015 by Utet Grandi Opere
English Translation Copyright © 2015 by Timothy Verdon

ISBN 978-1-64060-424-7

Translations from other sources are the translator's own, even when a source citation may be furnished in the notes.

Title page images:
Figure 1. External view of the Basilica of Saint Francis, Assisi
Figure 2. View of the interior looking toward the altar

The Library of Congress has catalogued the hardcover edition of this book as follows:
Verdon, Timothy.
 The story of St. Francis of Assisi : in twenty-eight scenes / Timothy Verdon.
 pages cm
 Includes bibliographical references.
 ISBN 978-1-61261-685-8
 1. Francis, of Assisi, Saint, 1182-1226. 2. Christian saints—Italy—Assisi—Biography. 3. Francis, of Assisi, Saint, 1182-1226—Art. 4. Christian saints in art. 5. Giotto, 1266?-1337—Criticism and interpretation. 6. San Francesco (Church : Assisi, Italy) 7. Bonaventure, Saint, Cardinal, approximately 1217-1274. Legenda maior S. Francisci. I. Title.
 BX4700.F65V47 2015
 271'.302—dc23
 [B] 2015023937

10 9 8 7 6 5 4 3 2 1

Published by Paraclete Press
Brewster, Massachusetts and Barga, Italy
www.paracletepress.com

Printed in China

CONTENTS

INTRODUCTION

"The grace of God, our Savior, in these last days
appeared in his servant Francis. . . ."

I n these first words of the *Life of St. Francis* written in
1260–1263 by the Franciscan Bonaventure di Bagnoreggio
we find the key to the cycle of frescoes done thirty years
later in the basilica dedicated to this saint in Assisi. It is a key
that points to Christ: Bonaventure's words in fact rework a
New Testament statement alluding to the Savior's entry into
history: "For the grace of God has appeared, bringing salvation
to all" (Titus 2:11–12). This phrase is particularly familiar to
Christians because it opens a reading that from the earliest
Christian times until now the Church proclaims in the liturgy
of Christmas.

The theologian Bonaventure introduces Francis as closely
linked to Christ, that is, identifying the saint's life with that
of the Savior born of Mary. In the same way, the cycle of
frescoes commissioned—as Bonaventure's text had been—by
the Franciscan Order in the city of Francis's birth and in the
church that holds his mortal remains shows the divine grace that
"appeared" in this man who was already considered *alter Christus*,
another Christ: Francis. The cycle of scenes depicting episodes
from his life in fact illustrates Bonaventure's narrative, and
beneath twenty-seven of the twenty-eight frescoes paraphrases of

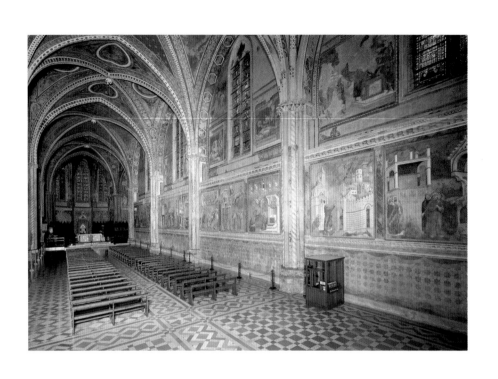

the relevant passages in Bonaventure's text are still legible.[1] These "captions" are reproduced in English translation in the part of the present volume dedicated to the individual frescoes, and further citations of Bonaventure's *Life* are furnished in the discussion of each scene.

Bonaventure's book is comprised of fifteen biographical chapters with ten others narrating Francis's miracles. Officially accepted at the general Chapter of the Order in Pisa in 1263, it was called *Legenda maior*, the "Greater Legend."[2] In medieval Latin the term *legenda* did not have the meaning that this word has assumed in modern languages—of "legendary," "fictitious," "fantastic"—, preserving rather the literal meaning of the Latin verb "to read," *leggere*, which in gerund form implied a necessity, almost an obligation: "something that absolutely must be read." In the same way the cycle of frescoes of the upper basilica is presented as "something that absolutely must be seen" in order to become familiar with the life of Francis.

In addition to the *Legenda maior*, two other texts shed light on the scenes from the saint's life: the Old and the New Testaments. On the same walls where the twenty-eight frescoes telling Francis's story appear in the register nearest the viewers, above them two other series of images are painted: Old Testament subjects on the north side, and, across from these, on the south side, scenes from the Christian Gospels. This grandiose Scriptural program, executed *before* the cycle depicting Francis, invites us to see the entire life of the saint as a modern extension of the Biblical *historia salutis*, the history of salvation. Some of the twenty-eight

Figure 3. An angled view of one of the two spans of the interior wall (to the right of the entrance) so as to give the idea of the dimensions of the frescoes of the Life of Francis with respect to the space.

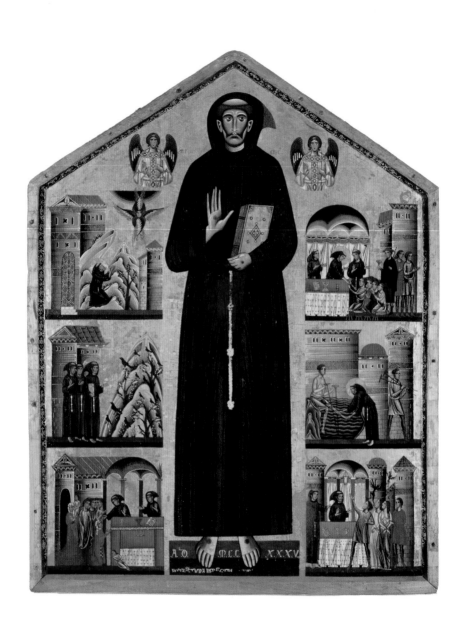

scenes showing Francis in fact relate him to personages from the Old Testament and to Christ in person, as our remarks on the individual frescoes make clear.

It was above all Francis's identification with Christ that the Order wanted to communicate in the cycle of the upper basilica. This theme is implicit in images for Franciscan churches from the very beginnings of the Order, and in a work painted barely nine years after the saint's death—a panel signed by the Lucchese master Bonaventura Berlinghiero and dated 1235 (fig. 4). The central figure's hieratic pose, and the way in which he salutes showing the wound of the stigmata in his right hand, configure an "icon" that is manifestly Christlike. In a work done a quarter century later, the so-called *Bardi Panel* (fig. 5), the identification with the Savior is further heightened by the fact that Francis's right hand is not greeting but *blessing*, evoking the image of Christ the priest offering himself on the altar of the cross. In Francis marked by the stigmata the Franciscans in fact saw the physical fulfillment of St. Paul's mystical assertion: "I have been crucified with Christ; and it is no longer I who live, but it is Christ who lives in me" (Galatians 2:19–20).

Christ lives in me: in these two examples of early Franciscan iconography, in addition to the hieratic figure of Francis who greets or blesses, there are also small scenes that narrate biographical episodes, as if to insist that Christ was present in the saint not only at the end of his journey but also at each moment of his human life. Comparing the 1235 panel with that of circa 1260, we find a noteworthy reinforcement of the biographical

Figure 4. Bonaventura Berlinghiero, illustration from 1235 with Francis and six stories from his *leggenda*, Pescia, San Francesco.

element, which from a mere six episodes of Francis's life has become twenty! The new interest in the life of the saint was to be the basis for the cycle of the upper basilica.

As we look at the two panels, we see that the criteria for selection and organization were also evolving: whereas in 1235 there were scarcely two episodes that can be called "biographical," the receiving of the stigmata and the preaching to the birds, with the other four scenes narrating *post-mortem* miracles, in the *Bardi Panel* fully fifteen scenes illustrate the life of the saint and only five show his miracles. Neither of these works respects the chronological sequence of the events depicted, although in the *Bardi Panel* at least the first scenes follow the order of Francis's life, suggesting a desire to reconstruct its historical development. Sequential chronology was not considered to be an absolute requirement, and in the *Legenda maior* Bonaventure admits that he has not "always woven the story according to chronological order," preferring at times "an arrangement that is more suited to bring out the concatenation of the facts."[3] The same organizational freedom is evident in the fresco cycle telling the story of Saint Francis's life in the upper basilica.

Whether in the writings or in the images that tell Francis's story, the intention of the Order was not only to present "the facts," but also to interpret in words and images something of the vibrant humanity of that extraordinary man. Toward that end Franciscan writers invented a style that had both popular appeal and refined psychological penetration: even before Bonaventure's *Legend* the two *Lives* of the saint written by Brother Thomas

Figure 5. Maestro della Palla Bardi, illustration (ca. 1260?) with Francis and twenty stories from his *leggenda*. Florence, Santa Croce.

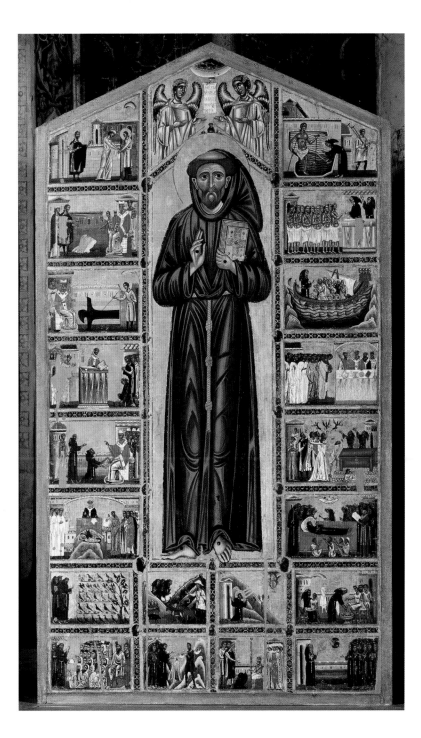

of Celano bear witness to this new literary style. An analogous direction is evident in paintings commissioned by the Order, but not in the first place in depictions of Francis, which for a long time remained linked to Byzantine stylistic elements, as is clear in the two panels just discussed. In the Franciscan context the humanizing impetus that would later transform European art appears first in the depiction of Christ, and especially in the suffering Christ. If we compare, for example, the archaic painted cross before which Francis had prayed in the church of San Damiano (fig. 6), and the cross made for a church of the Order around 1260, now in Perugia (fig. 7), the conceptual and stylistic differences speak for themselves.[4]

The cross of San Damiano, dateable to the middle of the twelfth century, presents Christ as impervious to pain and open-eyed: the *Christus triumphans* of early Christian tradition. By contrast, the later work presents him as suffering, a *Christus patiens* with figures of Francis and another friar at his feet in adoration. "You were left with his wounds, so fully did you have him in your heart!" a contemporary poet said to Francis, alluding to the stigmata,[5] and here the image has a similar ambition: it wants to mark the hearts of those who see it with a wound, just as Francis was "marked."

It is this need to transmit the sentiments experienced by the saint that changed Franciscan art. While on the old cross of San Damiano Christ remained a profile without plasticity, with muscles delineated in a conventional manner, this later one made around 1260 for the friars acquired real bodily weight thanks to its three-dimensional musculature modeled by light.

Figure 6. Anonymous, painted Cross known as "the San Damiano Cross," Assisi, Santa Chiara.

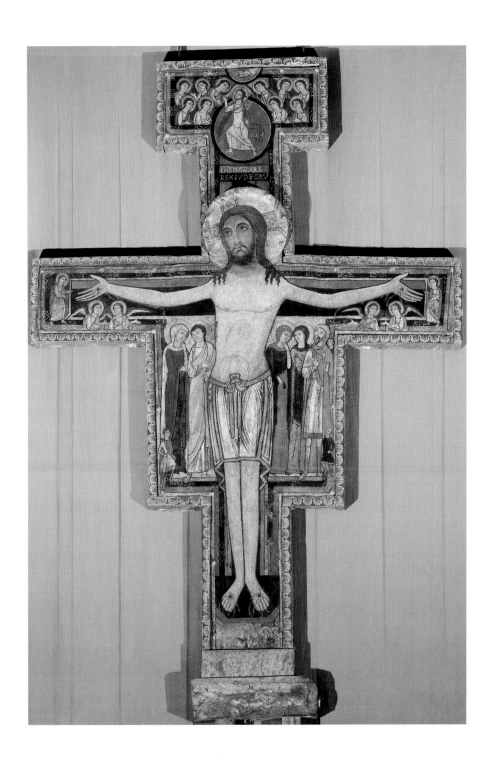

This effect is even more pronounced on the back of the "Perugia cross," where an extraordinary *Scourged Christ* (fig. 8) echoes the statuary of antiquity that, in that same year 1260, the sculptor Nicola Pisano began to imitate. In this figure the psychological and physiological dimensions in fact merge: the man bound to the column raises his head with a fluid and believable movement to look directly at the spectator, almost pleading for understanding and compassion. That is, the painter has succeeded in representing the Christ Francis saw: not a sacred character but a man of flesh who makes an appeal to other men on the basis of shared human feelings.

These early achievements of Franciscan art will be brought a new level of eloquence in the cycle of frescoes in the upper basilica, where the interactive humanity of the Christ portrayed on the Perugia cross becomes the hermeneutic key both of the protagonist, Francis, and of the secondary characters. The saint's body, his moving gaze, his inner growth in the framework of interpersonal relationships, the specific relationship of Francis with Christ and his gradual "conformation" to Him: these are the thematic conductive threads that give visible and dramatic unity to the twenty-eight scenes on the walls of the nave, painted in the register nearest to the faithful.

Among other unifying themes that should be mentioned perhaps the first is the emphasis on "stage space." In this age that reinvented in Christian terms several aspects of ancient theatre, and in the primary church of an Order that had begun to use sacred drama of its mission, it is indeed unsurprising that each

Figure 7. Anonymous, Cross painted on both sides: the front side with figures of Francis and Brother Leo at the feet of Christ. Perugia, National Gallery of Umbria.

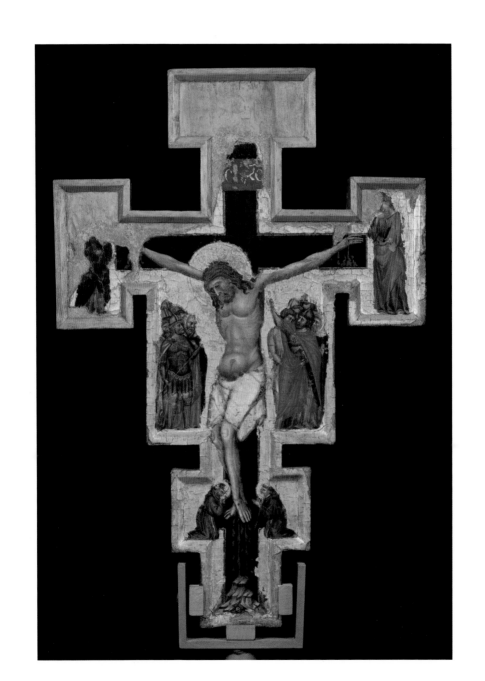

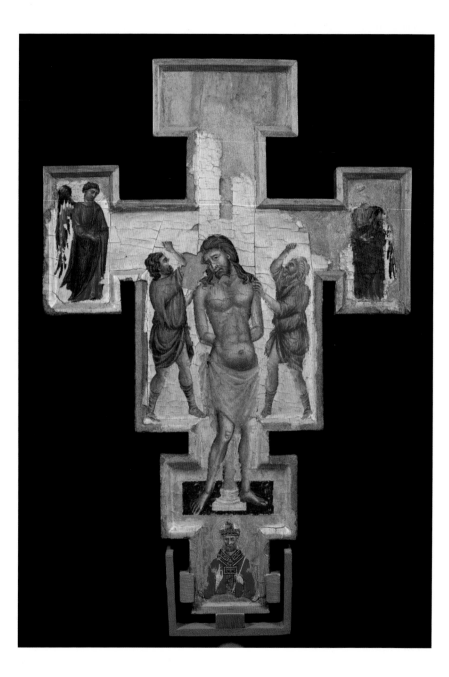

fresco of the *Life of Francis* appears to be a "stage" of limited depth, with a backdrop of apparently habitable "scenery" buildings. These stages are then framed with illusionistic classical architecture of considerable elegance, projected in perspective and at times with coffered ceilings. This is done in such a way that for visitors who followed the narrative sequence, advancing from one to another fresco, the effect was similar to that of the large medieval stages erected on several sides of a piazza, with distinct areas designated as "mansions" and "buildings" for the successive scenes of the drama.[6]

This extraordinary novelty—coherent and continuous stage space—is linked to the cycle's already mentioned physical and psychological emphasis. For in fact, if Francis had a real body and real feelings, it is clear that he must also have had real spaces in which to move. Thus, just as the sculpture of the time reactivated classic models in service of bodiliness, these frescoes draw on Roman pictorial prototypes from the age of the Roman empire in both their knowledge of perspective and in several specific "stage sets." Other of the constructions portrayed—the majority in fact—suggest intense interest in modern architecture: in many scenes, for example, there are elegant Gothic exteriors and interiors. In the stupendous *Manger Scene of Greccio* such "building realism" embraces even the church furnishings: the ambo, the roodscreen, and the elegant canopy above the altar.

These objects have a completely new level of visual definition for painting of this period, as is clear if we compare the fresco of *The Manger Scene of Greccio* with a mosaic of the same period in

Figure 8. The same: the back side with the scourged Christ who is looking toward the spectator.

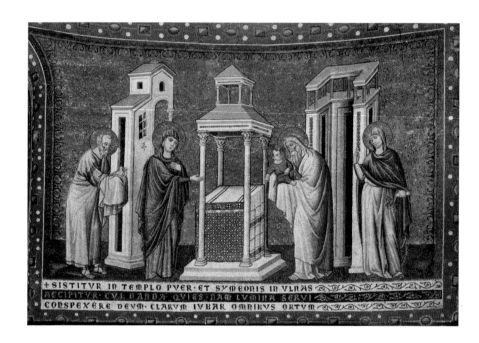

+SISTITVR IN TEMPLO PVER·ET SYMEONIS IN VLNAS
ACCIPITVR·CVI·DANDA·QVIES·NAM·LVMINA·SERVI
CONSPEXERE·DEVM·CLARVM·IVBAR·OMNIBVS·ORTVM

Santa Maria in Trastevere, in Rome: the *Presentation of Jesus in the Temple* designed by Pietro Cavallini (fig. 9). In both works a canopy covers the altar, but whereas Cavallini's is generic, the canopy portrayed in the upper basilica fresco is practically a photograph of the ones created a few years earlier by Arnolfo di Cambio for the Roman basilicas of Saint Paul Outside the Walls and Saint Cecilia. So too the *badalone* (reading desk) with a list of chants attached to the side, and the reverse side of the large cross on the dividing screen, with its wooden framework accurately delineated. Even the mechanism for raising or lowering the reading desk is depicted, as is the support that holds the cross in an inclined position facing the nave—as if the birth of the Son of God that Francis dramatized with the manger had conferred new dignity upon every material thing—upon each object, each implement—, since Christ, their Creator, would himself use these things.

The structured chancel area visible in *The Manger Scene of Greccio* suggests another theme of the pictorial cycle: the internal and external magnificence of churches and palaces. This emphasis probably had political importance in the new Assisi basilica, whose sumptuous decoration created disagreement within the Order; in any case it documented the reality of papal Rome from Francis's time onwards.[7] In addition, along with the architecture of single buildings entire urban agglomerations are shown, making "the city" a theme: a novelty fraught with meaning in an age of urban expansion.

The countryside and animals also become themes in this cycle dedicated to this saint who loved nature—Francis, who gave

Figure 9. Pietro Cavallini, Presentation of Jesus in the temple, mosaic. Rome, Santa Maria Maggiore.

orders to a wolf and preached to birds. Very beautiful and entirely new is the fact that the two scenes staged in completely natural surroundings, *The Miracle of the Spring* and *Preaching to the Birds*, are painted one beside the other on the internal facade, to the left and right of the entrance. This pairing could not be casual, because the frescoes illustrate nonsequential episodes, distant one from another in the *Legenda Maior*, just as they are distant from the episodes that precede and follow them in the pictorial cycle. Why then would the only two scenes lacking architectural elements be placed on the interior wall of the facade? I believe that the primary reason is emotional: looking back from the altar toward the entrance we have the impression that the wall of the inner facade *is not there*—that is, that the basilica is open to the cosmos. The scenes above these frescoes, *The Ascension of Christ* and *Pentecost*, have vast stretches of open sky, which—together with the two scenes below them—practically dissolve the interior facade, giving an ecstatic vision of the natural world. The effect must have been especially striking when the large facade doors were open to the meadowland outside the church.

Both the inner facade scenes are famous, but Francis's love for creatures has made *Preaching to the Birds* the virtual emblem of Assisi. In this fresco the character of the new pictorial style is moreover particularly clear. The same scene appears in the lower basilica, in a fresco from the 1250s (fig. 10), in which, however, the human body forms are flat and conventional, and only the birds seem to be alive! Forty years later, in the fresco of the inner facade, Francis and his companion have physical

Figure 10. Anonymous, fresco of the Preaching to the Birds, Assisi, lower basilica.

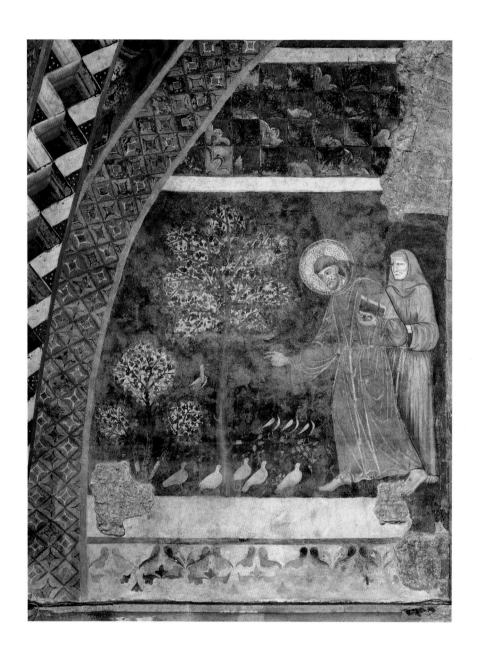

solidity and fluid movements. The folds of their clothing model their bodies, the trees have credible trunks and branches, and the birds themselves, more numerous than in the earlier work, almost have personalities: they seem to flock together to listen attentively to the words of the saint.

Let us note finally that in this scene in the midst of nature—as in others, placed in urban piazzas or inside buildings—Francis is shown in the company of his friars. Even in the moment of mystical contemplation at La Verna, when he receives the stigmata, a friar is shown near him. In these frescoes the friars appear as Francis's disciples, companions, witnesses and heirs, and the spectator senses that one of the functions of the pictorial cycle is to extol and celebrate the entire Franciscan Order together with its holy founder. The friars were in fact the commissioners and the first public of the frescoes, as they had been of Bonaventure's *Legenda*, whose full opening phrase is: "The grace of God, our savior, in these last days appeared in his servant Francis *to all who are truly humble and truly friends of holy poverty.*"

"Friends of holy poverty": the allusion applies first of all to the saint's followers who had taken "holy poverty" as their spouse. Thus, when Bonaventure explains the nature of his narration of the events, saying, "I have undertaken to not be concerned with literary elegance, considering that the reader's devotion will benefit more from simple language rather than from a pompous style,"[8] he is speaking of the option for "holy poverty." And this literary confession provides a precious key to the pictorial naturalism of the frescoes based on his text. In fact it is obvious that the literary influence of the *Legenda Maior* and the patronage of the friars transmitted the same preference for "simple language"

able to elicit fervor to the lay painters who, in the 1290s, created the frescoes. In this sense, the pictorial style they invented can and should be considered *Franciscan*.

Who were these painters? The historian Giorgio Vasari, writing in the middle of the sixteenth century, says that the Florentine Giotto di Bondone was "called by Brother Giovanni di Muro della Marca, at that time the general of the brothers of Saint Francis" to paint the entire cycle "in the upper church, under the corridor that spans the windows, on the two sides of the church."[9]

This affirmation, certainly based on older oral traditions, not only does not exclude but it even presupposes the collaboration of other master artists, and in fact even an untrained eye perceives such diversity of style as to spontaneously suppose that more than one artist executed these scenes. At the same time, however, the evident conceptual unity of the cycle makes clear that at the head of this team there must have been a single designer and director of the work. Today, after years of heated debate, most scholars have come back to identifying the principal artist of the Assisi cycle as the master painter named by Vasari, Giotto di Bondone. The many attempts to put this attribution in doubt have not in fact sustained prolonged critical assessment.[10]

Obviously at Assisi Giotto was not yet the painter who would decorate the Cappella Scrovegni or of the chapels in Santa Croce, but a still-young artist from Florence who had worked in Rome— just as the artist of the frescoes in the transept and apse of the upper church, the Florentine Cimabue, had done earlier. If then we recall that the building and decoration of the Assisi basilica were papal projects, it becomes reasonable to hypothesize that there were Roman as well as Tuscan masters among Giotto's

collaborators. Probably the new spaciousness and architectural interest are Roman elements, while the physicality and affective expressiveness of the personages depicted had Tuscan origins. To Giotto himself, beyond the general direction of the program, are due the fusion of these various orientations and the creation of a single formal and expressive language. In the frescoes of the upper basilica Giotto in fact took the first step toward what, a century later, became the Renaissance.

The cycle
of frescoes
in Assisi

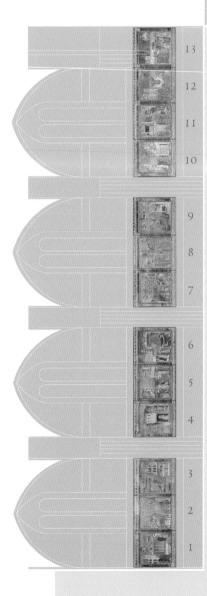

ENTRANCE

15

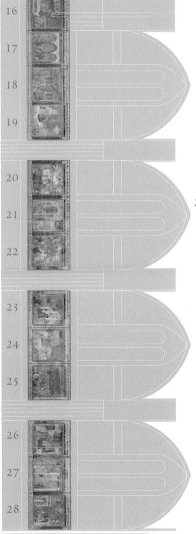

16

17

18

19

20

21

22

23

24

25

26

27

28

ALTAR

THE STORY OF
ST. FRANCIS OF ASSISI

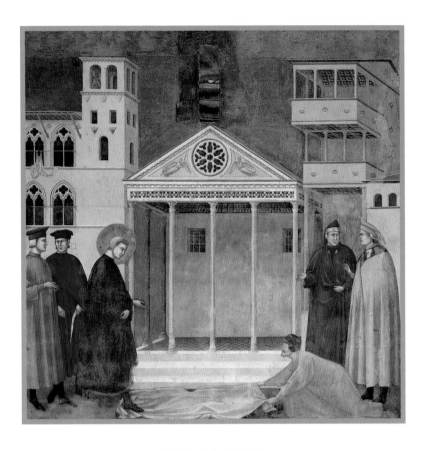

FRANCIS HONORED BY A SIMPLE MAN

A simple man from Assisi spreads his cloak on the ground
before blessed Francis and gives honor to his passing.
Inspired, he affirms, as is believed, that Francis is worthy
of every reverence, because he will soon do great things
and thereby should be honored by all.
—LEGENDA MAIOR I,1

The visual narrative of the life of Saint Francis opens with an absolute novelty: a view of the principal square of Assisi, at the center of which rises the Augustan-age temple, traditionally called the "Temple of Minerva," the most important monument of this small Umbrian city. Giotto thus insists on the verifiable historical content of the story that begins here, following Saint Bonaventure, who, in the prologue of the *Legenda Maior*, stated he had "gone to the places where [Francis] was born, lived, and died" in order to conduct "diligent inquiries into the facts with his surviving companions. . . ."[11] Giotto, that is, gives the pilgrim, who has also "gone to the places where the saint was born and died" (and who perhaps has already seen the piazza and the temple), the sensation of conducting "diligent inquiries." In this way, already in the opening episode, the artist situates his story in the realm of things worthy of faith because they are objectively verifiable, and indeed *seen*.

Bonaventure's text, however, mentions neither the piazza nor the temple, whose portrayal in the fresco thus represents a "revision," perhaps political in nature: in the second half of the 1200s the "Temple of Minerva" had been adopted as the seat of Assisi's local government, and its inclusion here probably alludes to the relationship of the friars with the city, which— thanks to devotion to Francis—had become an important place of pilgrimage.

But the real subject of the fresco is the encounter in which Francis receives the homage of "a simple man" and hears the prophetic announcement of his own glorious future: the emotional center of the scene is the glance that passes between

the young saint and the man who, prostrate, spreads a white cloak before him. While bystanders discuss the gesture and the words that have been pronounced, Francis himself, understanding and benevolent before the handicapped interlocutor, remains transfixed, perhaps remembering that cloaks had been spread on the ground in front of Jesus as well, at his entry into Jerusalem preceding the Passion (Matthew 21:8). In young Francis's gaze we read suspense: he hesitates and, still uncertain, opens himself up to the possibility that this man's words might be true—Bonaventure says "inspired"—and thus, with his right foot already on the cloak, he starts down the road that will conform him to Christ. The empty space at the center of the composition—the distance that separates Francis from the improbable prophet of his future—has extraordinary dramatic power, and defines the psychological hermeneutic of the entire cycle. Here the image not only introduces Francis's story, but reveals the inner drama experienced by this young man called by God.

This first scene of the cycle is half within the old chancel area of the basilica (toward the west), and half in the nave (toward the east).[12] The corbel that protrudes over the front of the temple originally supported a beam that marked the separation of the two spaces. This beam, which must have resembled the one portrayed in a fresco on the south wall, number 22, served as an iconostasis and supported, in its center, a large painted cross.[13] In this way the first step made by Saint Francis, in the opening scene, could already be read in relation to the paschal mystery of Jesus Christ.

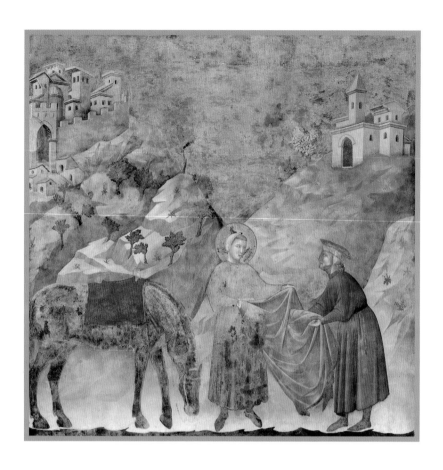

FRANCIS GIVES HIS CLOAK
TO A POOR MAN

*When blessèd Francis meets up with a knight who was noble
but impoverished and badly dressed, and, moved with respectful
compassion for poverty, immediately removed his own cloak
and clothed the knight in it.*

—LEGENDA MAIOR I,2

The second scene of the cycle too describes an encounter: one that occurred in 1204, perhaps: the meeting of Francis with a poor man to whom the saint gave his cloak. Bonaventure recounts that the young Francis had been ill for some time, but "having regained his physical strength, he obtained, as was his custom, fine clothing." *As was his custom*: the future saint was vain, that is, preoccupied with his own appearance. Bonaventure even alludes to Francis's dissolute life, specifying that he "had not yet learned to contemplate the reality of heaven. . . ." But the young man was also sensitive and generous, and upon meeting a nobleman who had fallen on hard times, sympathized with him "with loving mercy and pity." Giotto illustrates this capacity to deeply identify with another's situation, putting at the center of the fresco a Francis who looks with emotion at the man born well off but reduced to a poverty that humiliated him.

The saint then removed the clothing he had procured for himself and gave it to the knight. This was a spontaneous gift: the man had not asked for anything and in fact seems astonished, almost unbelieving. Although spontaneous, however, Francis's generosity replicated that of a hero of early Christianity, the soldier Martin of Tours, who, seeing one day a man suffering from the cold, divided his cloak in two to give the man half. Here Francis, giving his whole cloak, obviously surpasses Martin, and this fact would have struck medieval pilgrims.[14] And even the gesture is merely instinctive; this first "disrobing" or "emptying" is charged with meaning, prefiguring the definitive renunciation of worldly possessions to which Francis would later commit, in the scene depicted in the next bay, in an analogous middle position. The one and the other

renunciation bind Francis to Christ, "who, though he was in the form of God . . . emptied himself, taking the form of a slave" (Philippians 2:6–7).[15]

Bonaventure does not say where this encounter took place, but Giotto stages the episode in the countryside, under the walls of Assisi and near a village. Guided by the friars, he may want to associate the gift of clothing with an experience described by Thomas of Celano in which Francis, leaving for the country after his illness, was astonished at not finding pleasure in nature.[16] The man who would one day sing of nature's beauties in fact was oppressed by the attachment to riches, from which he still had to be freed in order to penetrate the meaning of the Savior's words: "And why do you worry about clothing? Consider the lilies of the field, how they grow; they neither toil nor spin, yet I tell you, even Solomon in all his glory was not clothed like one of these" (Matthew 6:28–29). Here, behind Francis who removes his clothing out of compassion, the boundless landscape becomes a metaphor for freedom.

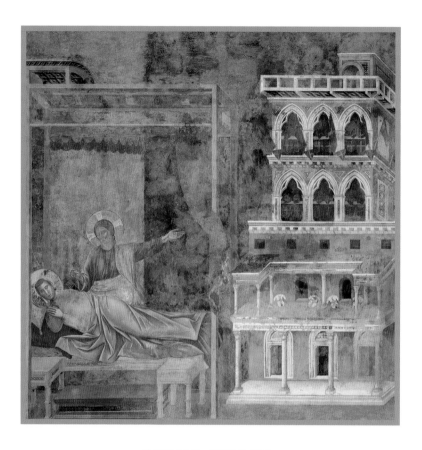

THE VISION OF THE PALACE
FULL OF WEAPONS

*The following night, as Francis slept, the Lord showed him
in a dream a marvelous palace, with many weapons bearing
the sign of the cross of Christ. . . . And when he asked
whose weapons they were, the divine voice replied that they
were all destined for him and for his knights.*
—Legenda Maior XV,4

In the third and final scene of this first bay, Giotto suggests the impact of the preceding experience on the young Francis, introducing the theme of the *revelatory sleep*: the sleep, that is, in which, while the body rests, the soul's questions receive answers. In Bonaventure's climate of psychological inquiry, this theme of Biblical origin is fundamental, and Giotto will several times portray personages in the Assisi cycle in a deep sleep.

The dream in which Christ appears to Francis is again modeled on the legend of the soldier Saint Martin, to whom the Savior appeared in a dream in a similar way to reveal that the half of the cloak Martin had given the poor man had been really given to Him. The dream apparition was in fact a validation of the action that had been accomplished. Something analogous happens here: to a young man attracted by the knightly ideal, Christ shows a palace adorned with trophies marked by the cross. And, in answer to Francis's question about the ownership of the weapons, Christ replies that they are for Francis himself and for his "knights."

The purpose of this vision, Bonaventure explains, was to show Francis "in a visual form how the mercy that he had shown toward the poor knight, for love of the high King, would be repaid with an incomparable reward." Thus the magnificent palace adorned with banners and armor—a sumptuous structure, Romanesque in the lower part, Gothic in the upper levels—is the real point toward which Giotto wants to attract our gaze, as is suggested by the eloquent gesture of Christ, who indicates it. With this vertical edifice on the extreme right of the image the artist in fact concludes the horizontal movement of

the first three frescoes: the saint's solemn walk onto the simple man's cloak in the first, and the transfer of his clothing to the impoverished nobleman in the second, now lead—beyond the body of Francis lying on the bed—to the palace symbolizing a future "reward." In compositional and narrative features, that is, the first three scenes invite us to proceed toward the east, where in the successive bays the protagonist's life will be progressively enlightened by Christ.

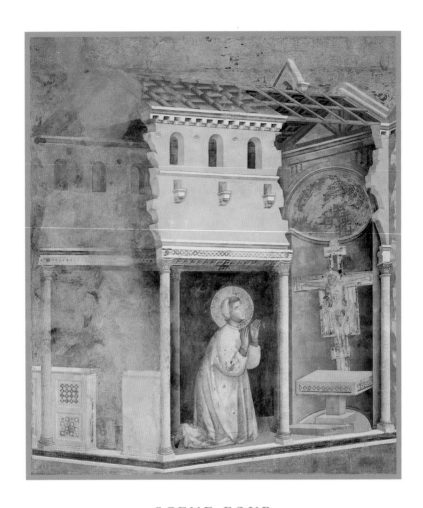

SCENE FOUR

THE PRAYER IN SAN DAMIANO

*Prostrate before the image of the Crucified One, he began
to pray . . . and he heard a voice, coming from the
cross itself, which said to him three times: "Francis, go
and repair my church, which, as you see, is completely
in ruins!", signifying by this the Roman Church.*
—LEGENDA MAIOR, II,1

From the dream-vision of a fortified palace we now pass to the reality of a small ruined church, the true beginning of the "reward" promised to Francis. More or less a year has passed—a year in which the young man had been ever more active in helping the poor—, when one day, "having gone out into the country to meditate," Francis felt himself spurred by the Holy Spirit to pray in the church of San Damiano "which threatened to fall into ruins, old as it was." He fell to his knees before an image of the crucified Christ (according to tradition, the one reproduced in our figure 6, today preserved in the church of Saint Clare in Assisi), and "as he fixed his tear-filled eyes on the Lord's cross, he heard with his physical ears a voice coming down toward him from the cross and telling him three times, "Francis, go and repair my church, which, as you see, is completely in ruins!"

Giotto—pushing his knowledge of perspective to the limit—shows us both the inside and the outside of San Damiano, even giving a glimpse of part of the inner ceiling through some beams exposed by the falling of tiles from the roof. The viewer grasps that before it fell into ruins this must have been a very beautiful church, with mosaic inserts in the cornices, on the partition screen, and on the altar on which the painted cross is enthroned.

The true subject, however, is neither the church nor the venerated cross but rather Francis, shown in intense prayer. It is in fact with this figure that Giotto introduces another of the cycle's visual and narrative keys, "Francis in prayer," a theme to which the artist will return in various ways fully nine times. Here the saint's prayer is colored with emotion at hearing the heavenly voice, and the raised hands that Giotto gives him suggest the psychological

and physical state that Bonaventure describes: "Upon hearing that voice, Francis is astonished and trembles in every limb, for he is alone in the church, and, perceiving the force of the divine language in his heart, experiences a rapture beyond the senses." This condition too—transfiguring ecstasy—will be the theme of several scenes of the cycle.

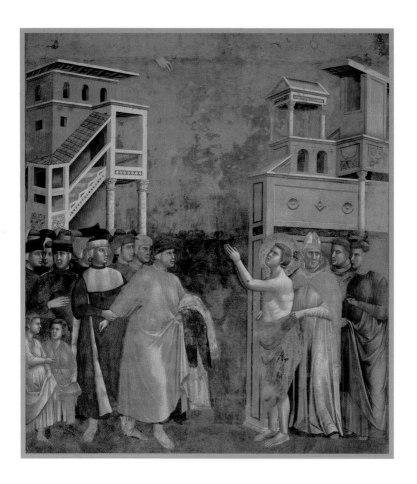

RENOUNCING WORLDLY POSSESSIONS

He stripped himself immediately of all his clothing and gave it back to his father . . . and turning to his father said, "From now on I can say with all truth, 'Our Father who art in heaven,' because Pietro di Bernardone has repudiated me."
—LEGENDA MAIOR II,4

T he second scene in this bay also represents Francis with his hands lifted in prayer, this time not to Christ but to God the Father. More time has passed and the young man has become ever more detached from the world of his "fleshly father," as Bonaventure calls the man who had sired Francis, one Pietro di Bernardone, a cloth merchant from Assisi. To finance the reconstruction of San Damiano, the future saint had in fact taken and sold expensive fabrics from his father's shop, leaving his father's house to live with the priest of San Damiano. Brought back and confined to the house by his father, he was subsequently freed by his mother.

The moment illustrated here is that in which, invited by his father to renounce his rights of inheritance, in early 1206 Francis not only appeared before the bishop to formalize this renunciation, but "allows no delay nor hesitation; he does not wait for anyone to speak; but immediately removes all his clothing and gives it back to his father." This embarrassing stripping is not initially total, however, and Francis, "intoxicated with an admirable fervor of spirit, also removed even his underwear in front of everyone, showing himself completely nude and saying to his father, "Until now I have called you my father on earth; from now on I can say with all confidence, 'Our Father who art in heaven,' because in Him I have placed my every treasure. . . ."

This dramatic distinction is why Giotto splits the scene into two opposing parts, a compositional solution to which he will turn only one other time in the cycle, in the fresco portraying *The Trial by Fire Before the Sultan*. Here the vertical division separates his father's populous bourgeois world, on the left, from the world Francis now chooses, on the right, whose

sparse members are the bishop of Assisi and a few clerics. The opposite characters of these universes are easy to read: while at our left the "fleshly father" trembles with rage and the crowd supports him, commenting on the scandalous event, at the right Francis—nude, as only Christ was shown at that time—places his trust in the heavenly Father, whose presence is indicated by the blessing hand on high. Bonaventure says that the bishop, moved by Francis's faith, covered him with his own cloak, and Giotto also portrays this action, in view of the theme central to several of successive scenes: the active support the saint would receive from the ecclesiastical hierarchy.

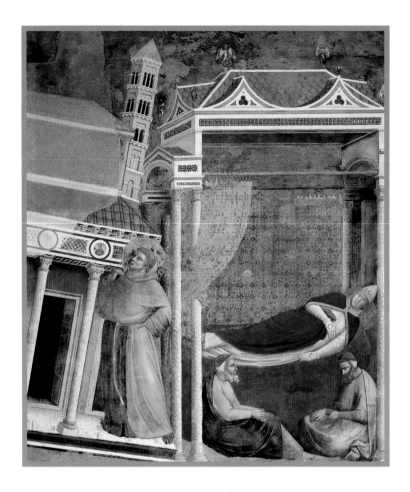

SCENE SIX

THE DREAM OF INNOCENT III

The pope had seen in a dream as if the basilica of the Lateran was about to crumble when a man, poor and little, modest and unassuming, with his shoulder leaning against it, was holding it up so that it would not fall.
—LEGENDA MAIOR III,10

S ince Francis's renunciation of worldly possessions more than three years have gone by, during which he has had various experiences, passing from his first idea of living as a hermit to one of going through the world preaching repentance. By this point he is wearing a religious habit and has gathered his first followers, for whom he has written a rule of life.

He decides then to seek papal approval of this project. The pope, Innocent III, plays for time though, seeing that some of his cardinals consider Francis's program of life excessively severe; yet Innocent does not forget Francis, seeing him several times in dreams. When the strange supplicant succeeds in speaking to him again, and recounts "the parable of a rich man who with joy had married a beautiful and poor woman and from her had had children who had the same physical appearance as the king, their father . . .," Innocent admits that in a dream he saw "that the Basilica of the Lateran was now at the point of falling into ruins, and that a poor fellow, small and contemptible in appearance, was supporting it, putting his shoulder to it so that it might not fall." Giotto shows us the pontiff asleep in the Lateran palace, with two advisers at the foot of the bed, while next to the palace, the basilica, tilting dangerously, is being held up by Francis.

Bonaventure's text and Giotto's fresco synthesize a series of complex historical realities, among which are these: the contemporaneous multiplication of movements embracing poverty, seeking to lead the Church back to the simplicity of the Gospels; the suspicion and hostility that these movements aroused in the Roman Curia; and the extraordinary—some would say "miraculous"—openness of the higher clergy to Francis and his

friars, who become mediators between the reform demanded by common people and the conservatism of the ecclesiastical institution. The splendor of churches of the period and the magnificence of prelates' palaces were notorious: Innocent III had mosaic decorations made for the old Vatican basilica and an entire new palace built "*apud Sanctum Petrum*" (next to Saint Peter's), and the glittering decorations and marble columns with which Giotto embellishes the portico of Saint John Lateran and the pope's pavilion, in the fresco, allude to the splendor found in similar Roman structures. In fact, at the time of this fresco the Lateran Patriarchate (then the official residence of the popes) had been modernized and enriched, so that the contrast that Giotto underscores between the "poor little man" and the luxury of the buildings dramatized the idea of a rich Church saved by Christ's paupers.

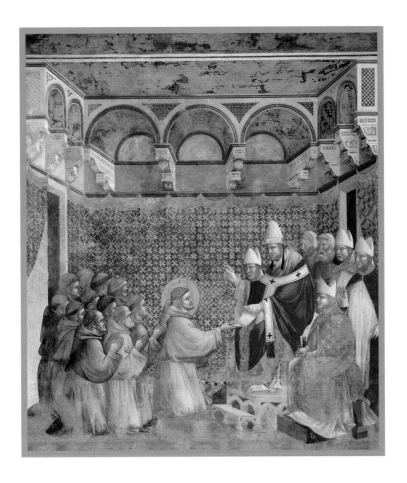

THE CONFIRMATION
OF THE RULE

*The pope approved the rule, gave Francis the right to preach
repentance and, for all the lay brothers who had accompanied
the servant of God, he had them given small tonsures, so
that they might freely preach the word of God.*
—LEGENDA MAIOR III,10

T his scene completes the meaning of the preceding one, showing Innocent III, who—after dreaming about the support that Francis could offer the Church—hands back the approved rule and imparts his blessing upon the handful of friars. What we just said of the magnificence of the papal court applies here as well: as the sumptuous curtains of the audience hall suggest, their luxury is in marked contrast with the coarse material of the Franciscans' habits.

Here for the first time we sense the strength of the collective identity of the Order. The kneeling friars behind Francis are visibly animated by a single spirit, a single purpose, even if the careful differentiation of their faces suggests the broad gamut of personalities and characters typical of every religious family. Giotto puts them all in an attitude of prayer, so that the obvious difference between them and the high prelates surrounding the pope does not communicate challenge or threat but reverence. Between these two groups there is moreover a tangible link: the sheet on which the rule is written, which passes from the pope's left hand to the right hand of Francis. With the approval of the new project by the *Pontifex maximus* the humanly irreconcilable distance between these two visions of the Church is "bridged."

We should also note the relationship of this fresco with the Old Testament scenes on the wall right above it. Above the figure of the pope blessing Francis we see, in the middle tier, *The Patriarch Isaac Who Blesses Jacob*, and then in the uppermost tier, *The Expulsion of Adam and Eve from Earthly Paradise*. It is not difficult to connect these themes: blessed by

his father, Jacob and his sons would form ancient Israel, just as Francis with his spiritual "sons," the friars, would help shape the renewed Church. (It is not a coincidence that the number of friars in the fresco, including Francis, is twelve, the number of the tribes descended from the sons of Jacob.) And under the image of Adam and Eve expelled for having committed original sin, we see the pope authorizing the Franciscans to preach repentance.

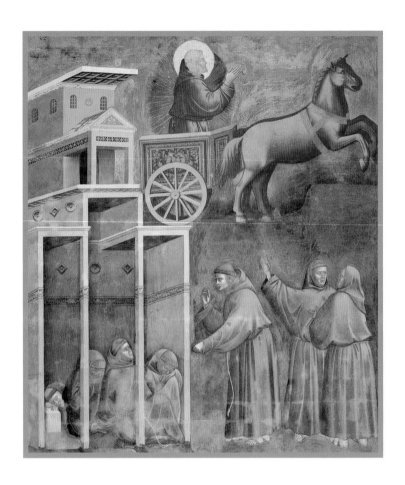

THE VISION OF THE
CHARIOT OF FIRE

*While this most devout man, according to his habit, was spending
the night in prayer in a small hut . . . and was therefore far from
his sons, around midnight—while some brothers slept and others
continued to pray—behold, a chariot of fire of great splendor
entered from the door and moved back and forth, circling the*

house . . . and it lit up the night with its splendor. The brothers who were awake were bewildered at such a sight; those who were asleep were awakened, and at the same time, filled with terror.
—LEGENDA MAIOR IV,4

Upon the approval of the rule there followed, in 1209–1210, a period of internal formation of the newly founded order. "The man of God, together with the other members of his company, went to live in an abandoned hovel near Assisi," in a location called Rivotorto.[17] Francis taught his fellow friars to pray praising God in all his creatures, and to revere priests and the whole Church; he himself used to go regularly to Assisi to preach in the cathedral.

And thus one night, when Francis was in the city, lodged in a hut in the canons' garden, the brothers who had remained in Rivotorto saw him in a vision carried up into the heavens in a chariot of fire, as the prophet Elijah had been (see 2 Kings 2:11). "Around midnight—while some brothers were resting and others were watching in prayer—a chariot of fire of marvelous splendor entered from the door of the house and three times circled the dwelling: above the chariot was a glowing globe, in the form of the sun, that dispelled the night."

This was a collective experience of extraordinary intensity, and "through the strength of the miraculous light the conscience of each one was exposed before the conscience of all." "Everyone understood, with a single thought, that in that chariot of light and fire the Lord was showing them their saintly father, absent in the body but present in spirit, transfigured supernaturally by the light of heavenly splendor and by the flames of heavenly ardor, in

order to indicate that they should walk as true Israelites, under Francis's guiding hand. He in fact had been chosen by God as a new Elijah to be both chariot and charioteer of spiritual men."

The meaning of this collective vision can be found in the Old Testament encounter that it harkens back to. The prophet Elijah was seen in the chariot of fire by the disciples that he had called to follow him: Elisha, his successor; and the "sons of the prophets" who formed—first with Elijah, then with Elisha—a sort of religious community. Knowing that his master was about to be taken up to heaven, Elisha had asked him, "Please let me inherit a double share of your spirit." To this Elijah replied that his disciple asked a hard thing, adding, however, "if you see me as I am being taken from you, it will be granted you; if not, it will not" (2 Kings 2:9–10). At the moment the master was taken away, Elisha did indeed see him in the chariot of fire and thus received a double portion of Elijah's prophetic power, exclaiming, "Father, father! The chariots of Israel and its horsemen!" (2 Kings 2:12)— the phrase that Bonaventure applied to Francis, the "new Elijah."

Let us note that this eighth scene again concerns above all the brothers, Francis's spiritual sons, who for this reason are "heirs" of a good portion of his prophetic power. It does not matter if, in the fresco, some friars continue to sleep and are not aware of the gift; the more attentive ones will rouse their brethren to full awareness of the shared Franciscan vocation.

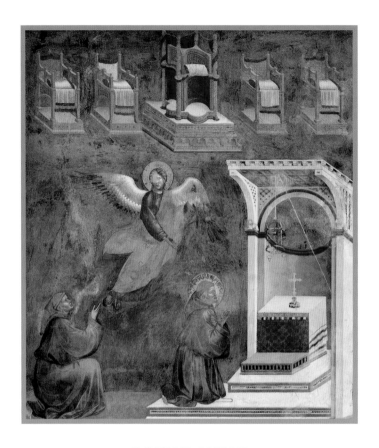

SCENE NINE

THE VISION OF THE
HEAVENLY THRONES

———❖———

(Wall text no longer existent, reconstructed as follows:)
*A brother . . . rapt with ecstasy, saw in the heavens very
many thrones, among which there was one more sumptuous
than the others, richly adorned with precious stones and
dazzling in its glory. And behold . . . a voice said, "This throne
belonged to one of the angels who rebelled, and now it
is reserved for the humble Francis."*
—LEGENDA MAIOR VI,6

This episode again underscores the saintliness of Francis, showing him in prayer before the altar of an abandoned church: according to the later *Leggenda perugina* this would be the church of San Pietro di Bovara in the Spoleto valley.[18] The saint remained in prayer the whole night, sending his traveling companion—one Brother Pacifico di Ancona, whom the *Leggenda perugina* calls "the king of poets"—to sleep in a nearby refuge for lepers. When Pacifico returned to the church the following morning he found Francis still before the altar, and, kneeling to pray with the saint, had a vision of gem-studded thrones in the sky. Among these one was more magnificent than the others, and Pacifico heard a voice explain that this throne was destined for Francis.

Giotto suggests the visionary character of the event, making the church dissolve almost entirely from view; all we see of it is the sanctuary and altar. Francis's long nocturnal prayer is evoked by lamps suspended in front of the altar in a metal housing: a technical element of surprising realism, with even a cylindrical roller that lets the rope supporting the housing go up and down, basket fashion. Giotto transforms the voice heard by Francis's companion into a visible angel, who—positioned in the center—becomes the compositional linchpin of the image: head turned down, the angel seems to answer the implicit question of Fra Pacifico, whose right hand indicates the most beautiful throne in the sky. With his left hand the angel too points to the throne, while with his right he indicates Francis.

The literary convention of the "throne in the sky" is biblical. "As I watched, thrones were set in place, and an Ancient One took

his throne. . . . The court sat in judgment, and the books were opened," Daniel 7:9–10 says, and Revelation reuses the image: "Then I saw thrones," says the author in 20:4, explaining that they are destined for the martyrs who had refused to worship Satan. The figure of the throne therefore suggests a place from which behavior is judged, a place destined for heroes who have earned the right to sit in judgment. In other biblical texts, though, the arrogance of earthly rulers is punished in the same manner as that of Lucifer, with their being cast down from a high throne (Isaiah 14:12–15; Ezekiel 28:1–19). The entire sixth chapter of the *Legenda Maior*—the chapter in which this vision of the heavenly thrones is narrated—in fact illustrates Francis's humility, just as the vision signals the fulfillment, in the Poor Little Man, of Christ's words: "All who humble themselves will be exalted" (Matthew 23:12b).

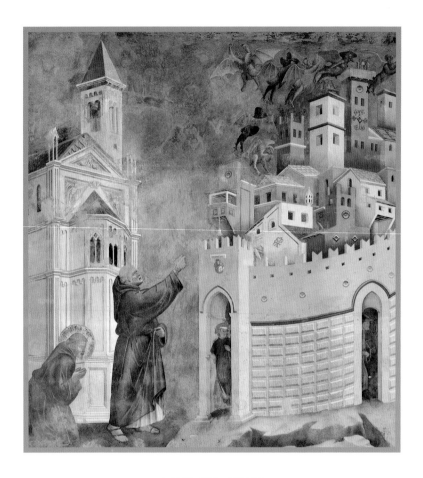

CASTING OUT THE DEMONS
FROM AREZZO

*Over the city the saint saw many exultant demons, and said
to his follower, "Go before the gate of the city and in the name
of God command the demons to go away at once." Like one
accustomed to obey, the friar began to shout loudly and the
demons fled, and immediately peace returned.*
—LEGENDA MAIOR VI,9

In an era of general expansion of European cities, Giotto describes Arezzo, from which demons were expelled through a friar's preaching. The episode alludes to the overcoming of discord engendered by factiousness, and the artist suggests the complex social reality of his time, putting men of different classes in the two city gates: an elegant burgher in the main gate and a peasant with a donkey in the second. On the left, behind the Franciscan preacher, we see a projection of the new Arezzo cathedral, begun a few years before the execution of this fresco.

And beside the cathedral we see the sender of the peacemaking friar, Francis, absorbed in prayer. Actually, if we read the scene from left to right, the Poor Little Man bending forward in concentrated and intense prayer is the first figure we see, and this helps us to grasp that, as in the preceding fresco, the true theme is Francis as a man of prayer.

Bonaventure stresses the power of the saint's prayer, noting that Francis brought about the city's liberation from afar, being lodged not at Arezzo but in a nearby town. From that location "he saw over the city a jumble of demons inflaming the citizens, who were already excited, to do each other harm. It was to cast out those spirits of the air and fomenters of sedition that Francis sent Brother Sylvester, a man as simple as a dove," with the order to command the retreat of the demonic forces. Not the friar's words, however, but Francis's prayer saves the situation, and Celano recounts that the saint himself subsequently informed the inhabitants of Arezzo, "I know that you have been freed through the prayers of a poor man."[19] In similar fashion the later *Leggenda perugina* would insist that

the citizens of Arezzo found peace again "through divine mercy and the prayer of Francis."[20]

In the Perugia text the saint speaks to the citizens touched by this miracle, and his words offer a merciless analysis of the factiousness of medieval city states: "I am speaking to you as to people who were enchained by demons. You had bound yourselves and sold yourselves, like animals in the market, because of your iniquity. You had thrown yourselves into the demons' arms, exposing yourselves to the power of beings who destroyed and destroy others and themselves and who want to bring your entire city to ruin."[21]

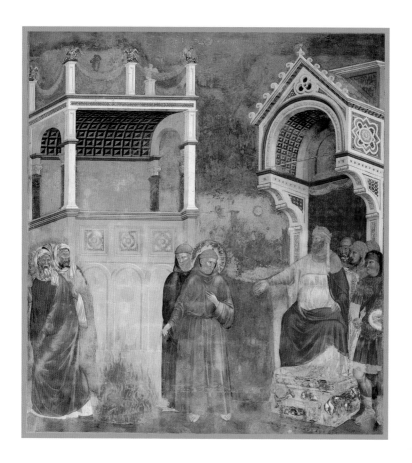

THE TRIAL BY FIRE BEFORE
THE SULTAN

*Blessed Francis, to bear witness to the Christian faith, wished
to enter a great fire with the priests of the Sultan of Babylon.
However, none of them wanted to enter with him but all fled
quickly from the presence of the Saint and the Sultan.*
—LEGENDA MAIOR IX,8

I n 1219 Francis finally realized his ardent desire to preach the Christian faith to the Muslims. This event is narrated in the *Legenda Maior's* ninth chapter, in which Bonaventure speaks about the charity that compelled Francis to want to announce the gospel to all people, and about the attraction that the possibility of martyrdom had for the saint. The function of this episode is in fact to associate Francis with the highest level of Christian sainthood, that of the martyrs, showing his complete willingness to die for Christ.

After he had reached the Crusader army in Acre and then at Damietta, Francis obtained permission from the papal legate to present himself, at his own risk and responsibility, before the Muslim prince, sultan Melek-el-Kamel. The sultan "listened to him willingly and strongly urged him to remain with him," but hesitated to accept Francis's invitation to be converted with all his subjects. Francis then asked him to have a fire lit, "the biggest possible," saying: "I, together with your priests, will enter the fire, and in that way, at least, seeing the evidence, you will be able to recognize which faith should be considered the most certain and the most holy." But the sultan replied, "I do not believe that any of my priests has the desire to expose himself to the fire and face torture to defend his faith." And Bonaventure adds here that the sultan in fact "had seen one of his priests, famous and of an advanced age, diasappear as soon as he heard the words of the challenge." At that point Francis offered to enter the fire alone if the sultan promised to convert should the saint emerge unharmed.

This is the moment that Giotto illustrates: Francis in the center who points to both the fire and himself, while on the

left the Muslim clerics slip away, and, on the right, the sultan, refusing Francis's offer to enter the fire alone, in turn offers him "many precious gifts . . . to distribute to poor Christians and to the churches, for the salvation of his soul." The saint however, "since he wanted to remain free of the weight of money," did not accept.

In this fresco, as in *Renouncing Worldly Possessions*, Giotto splits the composition from top to bottom, with the sultan and his court on the right and Francis on the left. At the root of the insurmountable distance between these two worlds is, once again, money, because while Francis is prepared to give his life, the sultan offers only "many precious gifts."

the earth with tears, beat his chest and, as though he had found a more intimate place of prayer, converse with his Lord. At times he answered the Judge, at times beseeched the Father, or again dialogued with the Friend. At other times the brothers who piously observed him heard Francis utter cries and groans as he implored the divine Goodness on behalf of sinners; he also wept out loud for the Lord's passion, as if he had it before his eyes. Once, while he was praying at night, he was seen with his hands extended in the form of a cross, lifted above the ground with his whole body and surrounded by a small, shining cloud: marvelous light diffused around his body, bearing marvelous witness to the resplendent light of his spirit."

Francis wept for Christ's passion, was seen with his hands extended in the form of a cross, and became transparent, the soul visible in his body: these are clear foreshadowings of the culminating stage of the saint's journey, the experience of the stigmata on Mount La Verna two years before he died. And since there is a fourth scene in this last bay, in the thickness of the basilica's entrance arch, our eye continues to follow the rising diagonal just described, going from Francis's raised arms in this scene to the outline of a large cross in the following one, *The Manger at Greccio*. And thus is completed the existential trajectory of the Poor Little Man here seen conformed to the crucified Christ in spirit as he would later be in his body.

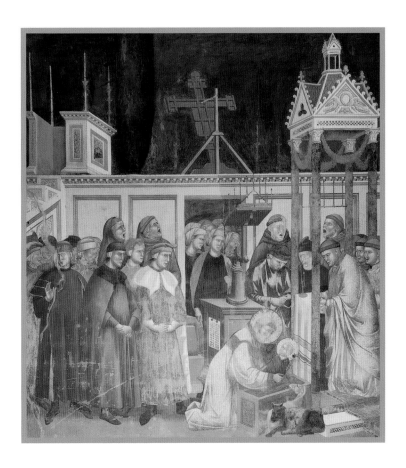

THE MANGER SCENE
OF GRECCIO

Blessed Francis asked that a manger be prepared in memory of Christmas, and that hay be brought and that an ox and a donkey be led to it. Then he preached about the nativity of the poor King, and while the holy man was in prayer, a knight saw the baby Jesus in place of the one the Saint had brought.
—LEGENDA MAIOR X,7

The event described is the celebration of Christmas in Greccio in 1223, when Francis, anxious to transmit his own emotion before the mystery of Jesus's birth, "had a stall prepared, had hay brought, and had an ox and an ass led to it," as Bonaventure writes. "The brothers gathered," he continues, "the townsfolk hastened to the site, and before the manger stood the man of God overflowing with devotion, shedding an abundance of tears, brimming with joy. The holy sacrifice was celebrated above the manger, and Francis, Christ's Levite, sang the holy Gospel. He preached to the people and spoke about the birth of the poor King, pronouncing whose name he tenderly called the 'babe of Bethlehem.'"

Giotto is very faithful to Bonaventure's text, showing us, together with Francis garbed as a "Levite" (deacon), numerous friars, the priest at the altar, and the men and the women of Greccio. In some respects the artist takes liberties, though: unlike the anonymous author of the *Bardi Panel*, for example (fig. 5), who in the same scene illustrated the singing of the Gospel, Giotto focuses attention on the saint's adoration of the child, leaving the task of evoking the proclamation of the Word to an ambo depicted in the upper left of the fresco.

The greatest liberty Giotto takes is that of staging the event in the presbytery of a church, whereas both Bonaventure and Thomas of Celano had situated it outdoors, in a wood. Giotto—presumably with the approval of the friars—offers a "pictorial revision" of the text material, perhaps meant to legitimize the costly basilica of Assisi that was still contested by some in the Order.

His fresco nonetheless translates the magic of the event: the intense emotion of Francis and of those who, on that night at the

end of December, were present at an unrepeatable event. He also fulfils Francis's desire to rekindle devotion to Christ's humanity: "I would like to represent the Baby born in Bethlehem," the saint says in Celano's *Vita prima*, "and somehow see with my own eyes the discomfort he experienced for want of the things that are necessary for a newborn child, and how he was laid in a manger resting on hay between the ox and the ass."[22]

The first person moved before the scene conceived in this way was Francis himself, we said. But the priest at the altar also turns to contemplate the Poor Little Man's gesture, and "experiences a consolation he had never felt before," as Celano noted.[23] Both of the biographers, then—Celano and, later, Bonaventure—confirm that the voice of Francis, when he sang the Gospel of the Nativity, was rapturous, filling all with heavenly yearnings.

In Giotto's fresco the human person, the physical surroundings of human life and the things that human beings use are described with a realism not seen in European art for a thousand years. Indeed, if we consider subject and style together, we can say that God's birth in the body, intensely experienced by Francis and his followers, invested with importance everything that served the body, and—like Francis who, when he stood before the manger in Greccio in 1223, was "vibrant with compunction and of inexpressible joy"[24]—so too Giotto, some seventy years later, vibrated with emotion before the humble things of which the Poor Little Man had spoken. He went so far as to organize structures and objects in depth thanks to a precocious but quite skillful use of perspective, in this spatial construction that is among the most complex attempted since the disappearance of Roman painting.

Nor is there a lack of symbolic references. The fathers of the Church reminded readers that the term *Bethlehem* means *house of bread,* and here Giotto places the food trough containing the baby (*the manger*) beside *the altar* on which bread becomes the Body that, as an adult, Christ would give as food; and it is no coincidence that the manger is placed beneath a large *cross.* The message of these interlocking symbols is clear: the baby's body, later offered on the cross, is the bread of eternal life.

In Giotto, however, the symbol is hidden in ordinary things, just as, in Christ, divinity was veiled by humanity.

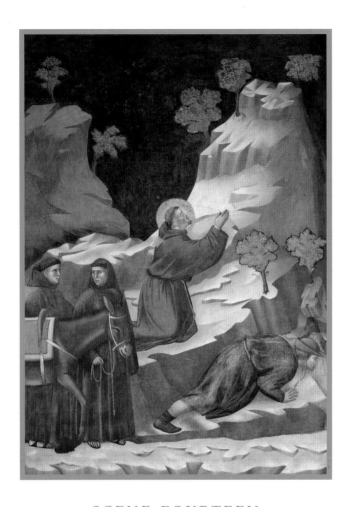

THE MIRACLE OF THE SPRING

*Because he was not well, Blessed Francis was riding a poor man's
donkey to ascend a mountain. The man felt as if he would die
from thirst, and Francis, praying, made water spring from a rock
in a manner never seen before or after.*
—LEGENDA MAIOR VII,12

A fter the complex architectural background of *The Manger Scene of Greccio*, Giotto now shifts the scene to a mountain setting, where Francis, who is ill, is going to devote himself to contemplation. It is hot, the route is "very long and full of difficulty," and at a certain point the rustic man on whose donkey the saint was riding up the slope began to scream, "I'm dying of thirst! If I don't find a little water soon, I'll die of thirst!" Francis then got off the animal and began to pray, later indicating to the man where he could find water.

The event recalls the thirst of the people of Israel during the exodus from Egypt, when in the desert they asked Moses, "Give us water to drink," and Moses, at God's command, caused water to flow from the rock (Exodus 17:1–7). Commenting on this event, Bonaventure said that Francis "was similar to Moses in that he made water flow from the rock."[25] The inclusion of this episode thus serves to complete the series of Old Testament parallels in scenes on the north wall, among which are Jacob, Elijah, and now Moses.

But *The Miracle of the Spring* is placed directly under the last fresco of the New Testament cycle developed on the south wall and inner facade: *Pentecost*. This means that Francis in prayer, at the center of *The Miracle of the Spring*, along with the same spring of water to which the thirsty man hurries, is directly beneath the group gathered at Pentecost—a group that includes Mary and the apostles upon whom the Holy Spirit descends in the form of a dove. Now, in Christian symbology, among figures that allude to the Spirit perhaps the main one is perhaps *water*: in the temple Jesus had cried out, "Let anyone who is thirsty come to me, and let the one who believes in me drink. As the scripture has said,

'Out of the believer's heart shall flow rivers of living water'" (John 7:37–38). The Gospel writer then explained that "he said this about the Spirit, which believers in him were to receive; for as yet there was no Spirit, because Jesus was not yet glorified" (John 7:39). In this fresco, therefore, Francis is presented as being not only "like Moses," but also like Christ—able to quench the thirst of all who long for the Holy Spirit.

In narrative and compositional terms, the juxtaposition of the saint who lifts his eyes to God in prayer, and of the material man who bends over to drink from the fount, is masterful: Vasari was especially struck by Giotto's capacity to communicate the drinking man's eagerness: "The desire for water is very life-like: the man drinks bent to a spring in the ground."[26] Masterful is Giotto's naturalism in describing the rock formation, the sweet-eyed donkey, and the saddle from which Francis has dismounted. And the water that gushes from the rock, fluid and fresh, is quite simply an inspired detail—as if Giotto had in mind the verse in which, in *The Canticle of Brother Sun*, Francis praised God "for sister Water, who is most useful and humble and precious and chaste."[27] The same could be said of the leaping flames in *The Trial by Fire Before the Sultan*, which recall the *Canticle's* next verse: "Praised be you, my Lord, for brother Fire, through whom you light up the night: he is handsome and merry and robust and strong."

But let us note a final touch: the placement of the spring in the lower right of the image puts it next to one of the two doors of the basilica, to the right of those crossing the threshold. More or less in that position it was the custom in churches to place a font of holy water, in remembrance of baptism. The painted water here

may have been seen, that is, above real water in the font, allowing believers to recognize in the drinking rustic man their own thirst for God. The eloquent glance exchanged by the two friars behind the donkey reassures us that in Francis and in his Order the living water of the Spirit will never fail.

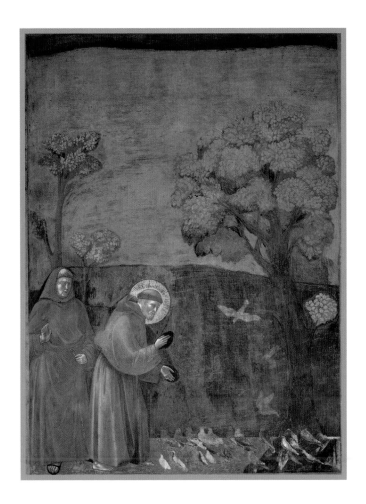

PREACHING TO THE BIRDS

As blessed Francis was going to Bevagna, he preached to many birds, which, excited and joyous, stretched their necks, beat their wings, opened their beaks, and touched his tunic; and all these things were seen by his followers waiting on the road.
—LEGENDA MAIOR XII,3

L ook at the birds of the air; they neither sow nor reap nor gather into barns, and yet your heavenly Father feeds them" (Matthew 6:26). It was perhaps this invitation by Jesus that suggested the theme of the sermon that Francis directed to the birds, saying, "O my winged brothers, you ought to praise your creator greatly, because it was he who covered you with feathers, who gave you wings to fly, who granted you the kingdom of pure air, and he it is who keeps you free from every care." In their own way, ther saint's listeners reciprocated: "The birds gesticulated in a marvelous manner, lengthening their necks, extending their wings, opening their beaks, fixing their eyes on him." Francis then "passed in the midst of them, with admirable fervor of spirit, and touched them with his tunic, without even one of them moving from its place."

This is what Giotto shows in this scene to the right of the second facade door: the saint who, as Celano said, "nurtured great pity and tender love even for the inferior and irrational creatures."[28] The theologian Bonaventure does not dwell on the tenderness that Francis experienced but presents him instead as a teacher of doctrine who, after his lesson to the birds, "tracing the sign of the cross, gave them his blessing and his permission" to withdraw. Giotto's fresco captures this deliciously serious mood, using the saint's gestures to illustrate his role as both a teacher who explains and a father who blesses.

This fresco too is linked with those of the second tier of the inner facade wall: *Pentecost* on the left and *The Ascension of Christ* on the right, directly above *Preaching to the Birds*. The Spirit who descends in the form of a dove upon the apostles, in *Pentecost*, prepares our eyes for the bird that glides elegantly

down from the tree to join its companions—a visual parallelism, this, of infinite poetry. And the juxtaposition of the figure of Francis who bends toward earth, in *Preaching to the Birds*, with the figure of Christ who ascends to heaven, in the *Ascension* overhead, echoes, while inverting it, the analogous juxtaposition of poses in *The Miracle of the Spring*.

Taken together, Giotto's two frescoes on the inner facade—each with a landscape sanctified by Francis's presence—illustrate Saint Paul's claim that "the creation waits with eager longing for the revealing of the children of God; for the creation was subjected to futility, not of its own will but by the will of the one who subjected it, in hope that the creation itself will be set free from its bondage to decay and will obtain the freedom of the glory of the children of God" (Romans 8:19–21). Finally, we should note that in composing these two frescoes to the right and left of the door, Giotto reproduced the actual lay of the land in front of the basilica. On the side where we see *The Miracle of the Spring* the terrain in fact rises toward the hill of la Rocca; on that of *Preaching to the Birds* it descends to the Porziuncola plain.

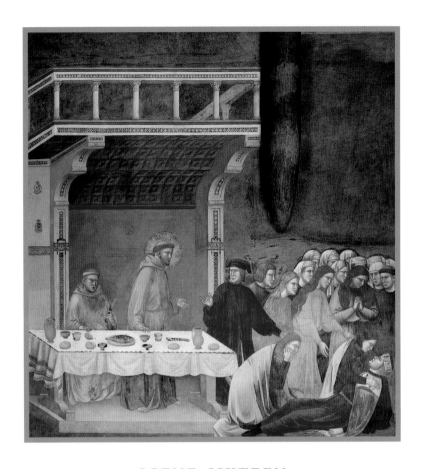

SCENE SIXTEEN

THE DEATH OF THE
GENTLEMAN OF CELANO

——•——

*Blessed Francis pleaded for the spiritual wellbeing of a knight
of Celano, who out of devotion had invited the saint to dinner.
This gentleman, after making his confession and setting his
household affairs in order, while the others took their place
at table, died unexpectedly and fell asleep in the Lord.*
—LEGENDA MAIOR XI,4

A fter the two scenes on the inside of the facade—taken, respectively, from chapters VII and XII of the *Legenda Maior*—the pictorial cycle now returns to an account of events that follows Bonaventure's sequence. The last scene on the north wall, the story of *The Manger Scene of Greccio*, was taken from chapter X, and this first scene on the south wall, *The Death of the Gentleman of Celano*, is from chapter XI.

Chapter XI of the *Legenda Maior* has the function of identifying Francis, who was without formal theological preparation, as an inspired interpreter of Scripture and a prophet. "In him the spirit of prophecy shone forth, so much so that it is true that he used to predict the future and used to read the secrets of hearts. . . ."[29] Thus it was that, invited to dine at a nobleman's home, the saint intuited that the man was about to die before his time, and said to him, "Quickly follow my advice, for today you will dine not here but elsewhere. Confess your sins right away." The man then made his confession to the saint's companion, a priest, and, at the beginning of dinner, "as the others began to eat, the host unexpectedly breathed forth his soul, stricken by sudden death, in accordance with what the man of God had foretold."

Giotto divides the scene into two zones: on the left is the laden table with Francis standing beside the seated priest who accompanied him; on the right are the other dinner guests who, astonished, crowd around the deceased knight. Quite marvelous is the group of five women in the foreground, who—with their hair loosed like that of the professional mourners of antiquity—bewail the dead man. Behind them there are other women, veiled, who, together with the first group, give a curiously female character to this area of the basilica. *The Death of the Gentleman of Celano*

stands in fact across from *The Manger Scene of Greccio* on the other part of the nave, where other women crowd the entrance to the presbytery.

The inclusion of this episode is due, at least in part, to the Christian hope of delivery from unforeseen death. But it is perhaps also due to the desire of the project sponsors to prepare the spectator for the three scenes that portray Francis himself as dead, farther along on this wall. In any case, the meaning of the prophecy addressed by the saint to the knight of Celano—namely that on that day he would eat "elsewhere"—becomes clear if one's gaze shifts to the upper tier, where somehat farther west *The Resurrection of Christ from the Tomb* is visible.

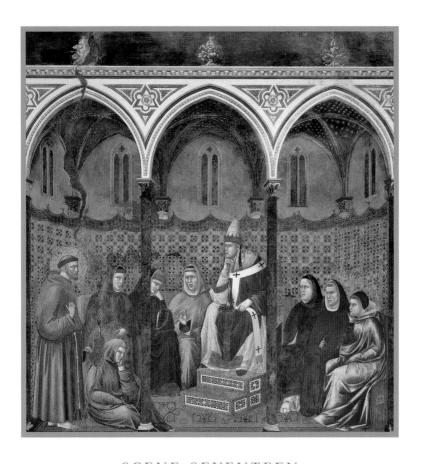

SAINT FRANCIS PREACHING
BEFORE HONORIUS III

*Blessed Francis preached before the pope and the
cardinals so devoutly and effectively that it was clear to
all that he spoke not with the learned words of human
wisdom but by divine inspiration.*
—LEGENDA MAIOR XII,7

I n a large Gothic hall whose gilt-ribbed vaulting has painted stars, pope Honorius III and six cardinals, all seated, listen to Francis, who stands before them as he speaks. A friar who has accompanied the saint sits on the ground.

Bonaventure explains that Francis, knowing he was to address the pontiff and the papal court, had memorized a speech that he had drafted with great care. "That notwithstanding, when he found himself in their midst, at the moment he was to pronounce those edifying words, he forgot everything and did not succeed in uttering a single phrase. Then, after exposing with humility and sincerity his embarrassment, he began to invoke the grace of the Holy Spirit. And immediately the words started to flow with such abundance and such effect, moving and touching the hearts of those illustrious persons, that it was clear that not Francis but the Lord's Spirit was speaking."

Giotto seems to linger over Bonaventure's claim that the saint's words succeeded in "moving and touching the hearts of those illustrious personages," and emphasizes a gamut of facial expressions in Francis's listeners that goes from skepticism to surprise, from meditative inwardness to open enthusiasm. The pope especially hangs on every word pronounced by the Poor Little Man, who points to himself with his right hand, as if to ask pardon for speaking spontaneously after preparing (and forgetting) a formal speech.

This scene too is linked to the images painted on the upper wall—not to *The Resurrection of Christ* previously mentioned, in the middle tier, but to *The Baptism of Jesus*, above it. At the Savior's baptism, "suddenly the heavens were opened to him and he saw the Spirit of God descending like a dove and alighting on

him" (Matthew 3:16)—an experience that Jesus later described using the words of the prophet Isaiah: "The Spirit of the Lord is upon me, because he has anointed me to bring good news to the poor . . ." (Luke 4:18; see Isaiah 61:1–2). Here we are meant to see Francis, like Christ, "under" the Spirit of God and by Him sent "to bring good news to the poor."

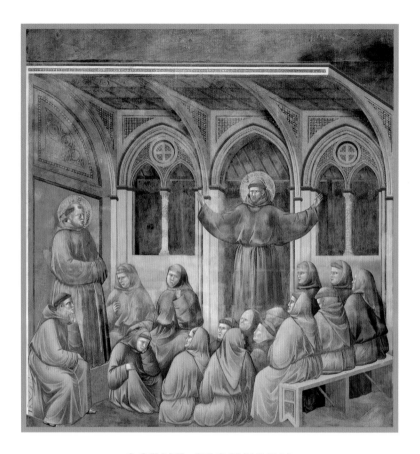

THE APPARITION OF SAINT FRANCIS AT THE CHAPTER MEETING IN ARLES

—◆—

In the Chapter meeting in Arles, while blessed Anthony was preaching on the subject of the cross, blessed Francis, who was corporeally absent, appeared and, extending his hands, blessed the brothers, as was seen by a certain Monaldo, and the other brothers rejoiced immensely at this.
—LEGENDA MAIOR IV,10

W hen, with the passage of time, the brothers had become very numerous, the attentive shepherd began to assemble them in one place, Santa Maria della Porziuncola, for the general Chapter," says Bonaventure, adding that "in the provincial Chapters, instead, [Francis] could not be present in person. . . ."

At the provincial Chapter meeting in Arles the saint, though he was absent, was nonetheless seen by a certain brother Monaldo. He appeared before the eyes of that brother "hovering in the air with his hands extended in the form of a cross [as he] blessed the brothers." These, in turn, even without seeing Francis, "felt themselves filled with a . . . great . . . and unusual spiritual consolation." Bonaventure links Monaldo's vision and collective consolation with the theme being developed by the speaker of the day, Saint Anthony of Padua: "The inscription placed on the cross, 'Jesus of Nazareth King of the Jews.'"

Let us also note that this scene is out of sequence: it is from chapter IV of the *Legenda*, while the two preceding ones were from chapters XI and XII, and the two succeeding ones are from chapters XIII, XIV, and XV. It is inserted here, I believe, for *visual* reasons: the saint's pose in the form of a cross in the apparition in Arles prepares the scene that follows, in which Francis receives the stigmata from Christ who extends his arms in exactly the same way. The figure of the Poor Little Man in Arles also replicates the one already used in another part of the nave, in fresco 12, where Giotto represented the ecstasy of Francis alone in the woods at night, as the saint audibly bemoaned "the Lord's passion, as if he had it before his eyes." That fresco—number 12—is in the same bay of the basilica as

this one, although closer to the door, so the visitor cannot help noting the repetition of the pose. Finally, above *The Apparition of Saint Francis at the Chapter Meeting in Arles*, in the middle tier of the succeeding bay Christ can be seen hanging on the cross with his arms in the same position.

A second function of this scene is then to show "the brothers [who] had by now become very numerous" of whom Bonaventure speaks. Counting Francis and Anthony of Padua (standing on the left), Giotto presents fully seventeen of them, thereby preparing the spectator for the teeming scenes of the funeral and the canonization of the saint. Here the careful differentiation of the faces, of the attitudes, and even of the diverse qualities of wool of the habits communicates the human richness of such numerical growth.

Among the details to note: the complex pose of Brother Monaldo, seated at Saint Anthony's feet; the splendid decoration of the Chapter room, with elegant Gothic mullioned windows and inlaid mosaic decoration; the refined spatial construction, which shows—in addition to the double windows and the door—the wooden cloister ceiling; and finally the handsome and sturdy bench at our right, suporting the ample posteriors of three friars.

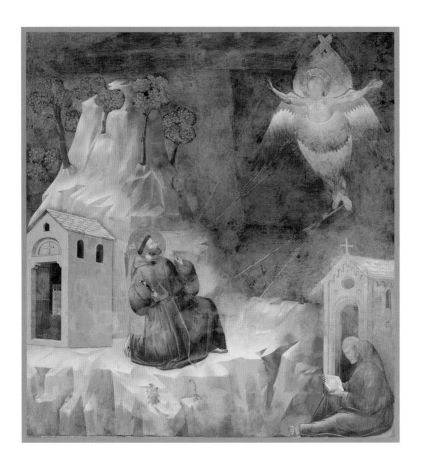

THE SAINT RECEIVES THE STIGMATA ON LA VERNA

As blessed Francis was praying on the slope of the mountain of La Verna, he saw Christ in the form of a crucified seraph, who impressed on his hands and on his feet and also on his right side the stigmata of the Cross of our very Lord Jesus Christ.
—LEGENDA MAIOR XIII,3

T his is the most important scene of the whole cycle, the moment toward which the entire itinerary leads. In 1224, "two years before he gave up his spirit to God," having withdrawn to Mount La Verna around the feast of the Exaltation of the Holy Cross (September 14), Francis understood that "since he had imitated Christ in the actions of his life, so he must be conformed to him in the sufferings and in the pains of his Passion, before passing out of this world." Then "he felt himself vigorously inspired and motivated to face martyrdom" and "the seraphic ardor of desire . . . bore him rapturously to God, and a tender feeling of compassion transformed him into the One who had desired, through an excess of charity, to be crucified." In that state of soul the saint saw "a figure like that of a seraph" between whose wings there was "a crucified man," and he understood that "he, the friend of Christ, was to be completely transformed into the visible portrait of Christ Jesus crucified, not through the martyrdom of the flesh, but through the fire of the spirit." As it disappeared the vision left the marks of Christ's wounds on the hands, the feet, and the side of the saint, and thus—concludes Bonaventure in paragraph 5 of the same chapter XIII—"the true love of Christ had transformed the lover into the very image of the beloved."

Giotto's fresco holds our attention for the small number of its figures and its natural setting: the other scenes on this south wall are by contrast filled with people and (with a single exception) placed inside or outside of architectural structures. In the already developed Franciscan iconographic tradition, moreover, this scene by Giotto distances itself from earlier

interpretations of the event (see figures 4 and 5) through several significant new features: the first is the inclusion of two little chapels, intended to identify the place with the then newly founded sanctuary of La Verna.

The second innovation is the presence of a "witness": a friar shown reading in front of the little chapel on the right, without, however, noticing what is happening to Francis. This figure represents the confreres to whom the saint would successively reveal the gift he had received from the Lord, asking them if he should keep it hidden. Perhaps this person is that brother "Illuminato, in name and in grace," who then replied to the saint, "Brother, know that sometimes the divine secrets that are revealed to you are not only for you, but also for others."[30] The figure also has the function of attributing to the Order the merit of having made the sign of Francis's complete conformity to Christ—the stigmata—known to the Church.

The fresco is distinguished from preceding interpretations of the event especially for the psychophysical complexity of the principal figure, Francis, whose pose no longer has anything conventional or ritualistic (again see figures 4 and 5). Giotto's new capacity to translate emotion in movement—already seen in the rustic drinker hunched over the spring and in brother Monaldo in Arles—here reaches a level unheard of in the thirteenth century; unsurprisingly the artist will repeat this composition several times in the decades to follow. Here the saint's three-dimensional body—shown in a difficult angled view, the right leg pulled back in the depth of the rock formation—opens slowly to the rays that emanate from the crucified Man he contemplates between the seraph's wings.

Beyond this visionary figure, Francis's transfigured face seems lifted to the image of Christ upon the cross in the middle tier of the succeeding bay.

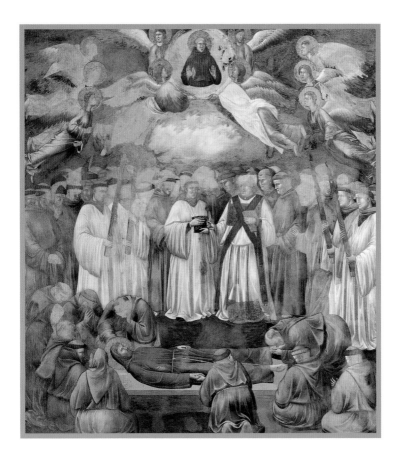

SCENE TWENTY

THE DEATH OF SAINT FRANCIS

*At the moment of blessed Francis's passing, a brother
saw his soul ascending to heaven under the form
of a most beautifully radiant star.*
—LEGENDA MAIOR XIV,6

After the image of Francis's body moved by love to welcome the stigmata, Giotto now shows the corpse of the saint who died at the Porziuncola on the evening of October 3, 1226. This is the first of three frescoes that, with more or less the same formula, focus their attention on Francis's body, and they remind us that the real treasure of the Assisi sanctuary is not the art that abounds there, but rather *the Poor Little Man's body* preserved—in Giotto's time—under the altar of the lower basilica. The visual repetition of the body lying in death thus has the function of preparing the pilgrims to go down into the crypt to venerate the saint's mortal remains.

Among other themes repeated here and in the following scenes are these: the indisputable holiness of the Poor Little Man, the authenticity of his stigmata, and the role of the Order in supervising people's veneration of the founder. In this fresco, for example, a kneeling brother on the lower left, looking up from Francis's body, in the center of the upper part of the fresco sees "the blessed soul, in the form of a beautifully radiant star, rising in a small, pure cloud . . . and entering heaven straightaway." At the center of lower foreground, then, Giotto places the saint's wounded hand, held tenderly by a friar seen from behind. A little farther to the left, the wound in Francis's side is visible through a rip in his habit, while, on the right, a friar contemplates one of Francis's feet, and another kisses the other.

And last, above the brothers' "bewailing" (which visually echoes *The Bewailing of the Dead Christ* in the middle tier of the preceding bay), Giotto shows a great number of friars around the priest who blesses the corpse. This throng of people serves to involve pilgrims, who generally come to Assisi in groups: the artist

reassures the crowd present in the basilica that the veneration of Francis's body has always been an experience shared with many others.

SCENE TWENTY-ONE

THE VISIONS OF
BROTHER AGOSTINO AND OF
THE BISHOP OF ASSISI

*The Order's minister in Campania, ill and near life's end, having
already for some time lost the gift of speech, cried out and said,
"Wait for me, Father, I am coming with you." And then he
immediately followed the saintly Father in death. In addition,
the Bishop of Assisi, furthermore, then on the mountain dedicated
to Saint Michael the Archangel, saw blessed Francis who told
him, "See, I am going to heaven."*
—Legenda Maior XIV,6

This fresco completes the preceding one, narrating the visions two men had at the very moment Francis died.

Here again the Order has the first place, and—reading from left to right—we immediately see a dense group of friars surrounding a confrere who is being helped to rise from his bed. This is a certain Fra Agostino, the "minister" (administrator, superior) of the Franciscan community in the "Land of Work" (the term used for Campania, near Naples). Fra Agostino, "who was . . . at life's end and had for some time lost the ability to speak, all at once was heard to exclaim, 'Wait for me, Father, wait for me. See, I am already coming with you!'" The friars assisting him "asked, amazed, to whom he was speaking in such a lively manner. He replied, 'Do you not see our father Francis, who is on his way to heaven?'", and then he expired.

On the same night of his passing Francis also appeared to the bishop of Assisi, who was at the sanctuary of the Archangel Michael on mount Gargano, and told him: "See, I am leaving the world and going to heaven." This is the episode portrayed on the right half of the fresco, where we see the prelate in full ceremonial attire on his bed.

Combining these two episodes, Giotto only follows Bonaventure, who had underscored their simultaneous occurrence. With a series of details the artist insists however on the difference between the "worlds" that received confirmation of the saint's arrival in heaven—a distinction, this, that cannot be found in Bonaventure's text. Fra Agostino and his brethren occupy a bare Gothic structure whose simple forms call to mind the Order's

church in Naples—San Lorenzo, begun in 1280—or perhaps the Franciscan church in Florence, Santa Croce, begun at about the same time as the fresco and then under construction. The bishop of Assisi, by contrast, sleeps in a chamber with rich hangings and a magnificent carpet. Even the two beds are clearly different: Fra Agostino's is a functional wooden structure with a thin mattress supported by rope mesh; the bishop's bed, by contrast, is luxurious, comprised of several mattresses with clean white sheets.

The function of this contrast is to insist that Francis's saintliness has importance not only for his friars and for the poor that they represent and serve, but also for the whole Church, including the high clergy who guide and govern it.

THE ASSISIAN NOBLEMAN GIROLAMO BECOMES CONVINCED OF THE REALITY OF THE STIGMATA

Blessed Francis lying dead in the Porziuncola, master Girolamo, the famous doctor and man of letters, moved the nails and, with his own hands, inspected the hands, feet and side of the Saint.
—LEGENDA MAIOR XV,4

Bonaventure says that after Francis's death, his body "by means of a never-before-seen miracle anticipated the image of the Resurrection." The "miracle" consisted in the fact that the signs in the hands and in the feet of the saint appeared like "nails . . . of the same substance as the saint's flesh" and "from wherever one exerted pressure instantly became erect, like nerve-ends joined together and hard. . . . [They were] black, like iron, while the wound in the side was red and . . . had the appearance of a most beautiful rose."[31]

The news of this phenomenon spread, and "a sea of people rushed upon the spot: they wanted to see this wonder with their own eyes, to drive away any doubt from their minds and to increase their emotion with joy." In the crowd there was also "a learned and prudent gentleman, Girolamo by name, well known among the people," who, "given that he had doubted these holy signs and was unbelieving like Thomas, zealously and audaciously moved the nails and the saint's hands in the presence of the brothers and of the other citizens, with his own hands feeling Francis's feet and side, in order to surgically remove the wound of doubt from his own heart and from the hearts of all. . . ." This fresco narrating the skeptic's verification of the authenticity of the stigmata serves to "surgically remove the wound of doubt" from the minds of the pilgrims as well.

Giotto inserts the verification operated by Master Girolamo (whom we see kneeling alongside the corpse) in the context of the saint's solemn funeral liturgy, and shows the priest in a black cope reading the rite flanked by acolytes and surrounded by candles. This event is situated in the church of the Porziuncola, whose curved apse occuies the background. Francis's catafalque, covered

with a precious drape, is placed just in front of the dividing beam between the nave and the presbytery, which must be similar to the beam then still dividing these areas in the upper basilica. In the fresco the beam also serves as an iconostasis, so that the saint's body is seen beneath images of the Madonna with the Christ Child, of the Cross of Christ, and of Saint Michael the Archangel, to whom the saint was especially devoted. These icons lean forward toward the people, with support mechanisms similar to the one that can be seen in *The Manger Scene of Greccio*. In front of the images hang two Eucharistic vessels covered with veils and a basket-shaped housing of metal with seven lamps.

In the crowd that Giotto represents, in addition to the Franciscans there are also many laypersons. Bonaventure affirms in fact that "the citizens of Assisi, in the greatest number possible, were admitted in order to contemplate and to kiss those sacred stigmata."

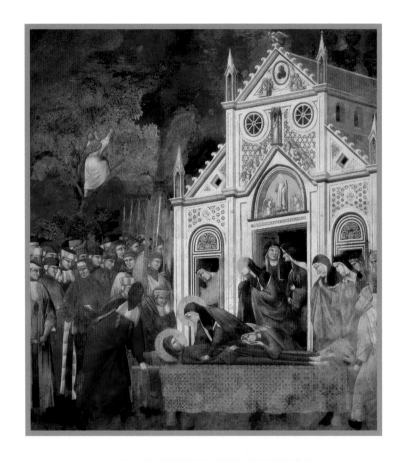

SCENE TWENTY-THREE

THE CLARETIANS MOURNING
OVER THE SAINT'S REMAINS
AT SAN DAMIANO

*The crowds that had gathered to accompany the holy body
adorned with heavenly gems to the city of Assisi waved branches
and carried many lighted candles; they brought the corpse for
blessed Clare and the other holy virgins to see.*
—LEGENDA MAIOR XV,5

This third fresco narrating Francis's funeral confirms the intention of involving pilgrims in the collective fervor of the rites that had been celebrated in far-off 1226. Bonaventure recounts that the night on which the saint expired—October 3—was dedicated to a prayer vigil at the Porziuncola, but that, "when morning came, the crowd, with tree branches and a great number of torches, accompanied the holy body into the city of Assisi with hymns and songs. They made a stop at the church of San Damiano as well, where noble Clare, now in heaven's glory, at that time lived along with her virgins. There they made a short pause with the holy body, proffering it to those holy virgins, so that they might see it decorated with celestial pearls and kiss it."

Following Bonaventure, Giotto shows the crowd, with some people waving the branches that a boy in a tree cuts for them. Above all he shows the reconstructed church of San Damiano (whose ruined state is visible on the other side of the nave, in fresco 4), and the sisters who, leaving the church, throw themselves upon the body. Clare herself embraces Francis and looks upon his face, but unfortunately Clare's own face is damaged and we cannot grasp her expression. Another sister bends to kiss Francis's left hand, and still others hasten toward the "holy body" that bears the signs of the stigmata.

Let us note that the brothers who accompany the body are fewer in number; rather, in addition to the sisters, Giotto emphasizes the massive presence of layfolk, as if to indicate that Francis now belongs to everyone, not only to the Order. In the framework of the relationship between the religious community responsible for the sanctuary and the civil authorities, it probably made sense to

recall that the people of Assisi themselves had carried the corpse into the city.

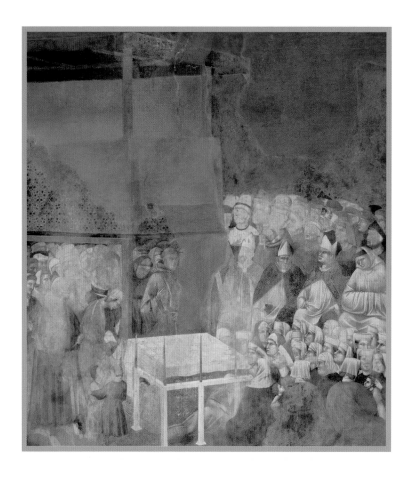

SCENE TWENTY-FOUR

THE CANONIZATION OF
SAINT FRANCIS

*When the pope, who had come in person to the city
of Assisi, after diligently examining the miracles and
hearing the friars' testimony, canonized blessed Francis
and inscribed him in the register of the saints.*
—LEGENDA MAIOR XV,7

T he theme of this last scene drawn from the *Legenda Maior* is the universal veneration accorded Francis. Giotto portrays the ceremony in which pope Gregory IX canonized the Poor Little Man of Assisi on Sunday, July 16, 1228. On the same day the pontiff laid the first stone of the lower basilica that was destined to hold the "holy body," which at that time had been placed in another church of Assisi.

Unfortunately, serious damage to the fresco has erased the image of the pope, who presumably stood on the richly decorated platform toward which many of those present turn their gaze. In front of the platform there is an altar enclosed by a balustrade with candles, and in fact the ceremony was the prelude to a Mass celebrated by Gregory IX in person.

Bonaventure, fully aware of the risk of a canonization such a short time after the candidate's death, underscores the fact that Gregory IX had entrusted the assessment of Francis's life and miracles "to those among the cardinals who seemed the least favorable." These however unanimously approved the proposal to elevate the Poor Little Man of Assisi to the catalog of the saints. One of the functions of this scene in fact is to show that the highest Church authority had given its seal of approval to the *cultus* of Francis.

Bonaventure's text, theological in character, does not offer details about the canonization rite, speaking only of "extremely solemn ceremonies, which it would be lengthy to narrate." But Thomas of Celano—in his *Vita Prima* composed a few months after the event, at which the author had indeed been present—, dedicates several pages to it, which Giotto's fresco summarizes. According to Celano, on July 16 "bishops, abbots, and prelates

hastened and joined together, coming from the farthest regions of the earth; also present was a king and a great multitude of counts and magnates . . . The scene's dominant figure, at the center, was the supreme pontiff . . . with the crown on his head in token of glory and holiness. Adorned with the papal infula and sacred vestments latched with gold buckles that sparkled with precious stones, the Lord's Anointed appeared in the splendor of his glory. . . ."[32]

The pope spoke about Francis and was moved to tears. Accounts were read of the saint's miracles, and the pope shed more tears, as did the other prelates who were present. Then "the blessed pontiff, with his hands raised toward heaven, in a thundering voice shouts the words of canonization" ['shouts,' because there were no microphones], and then together with the cardinals intones the *Te Deum*. "The crowd responds singing the Lord's praises in chorus. The earth echoes with a tumult of voices; the air is filled with hymns of glory, the ground is bathed with tears," and at the end, Gregory IX descends to the altar "and with joyous transport kisses the saint's tomb," which had been placed, one presumes, beneath the altar table on which the pope at last says the Mass.[33]

This is how Celano ends his account of the life of Francis, and Bonaventure also finishes with a mention of the canonization. Indeed, in Giotto's cycle the four remaining scenes have the character of an appendix: they narrate some of the saint's miracles to demonstrate the legitimacy—indeed, the *necessity*—of his canonization.

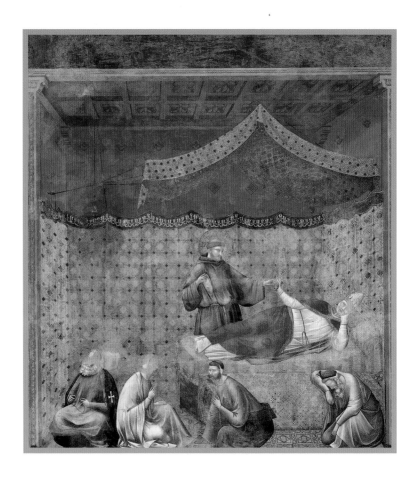

THE APPARITION TO GREGORY IX

*To Pope Gregory, who had doubts about the wound
in blessed Francis's side, the saint said in a dream: "Give
me an empty vial." This was done and the vial was
seen to fill up with blood from the side.*
—DE MIRACULIS I,2

The scope of this and of the following three scenes is explained clearly in Saint Bonaventure's treatise on Francis's miracles, a sort of appendix to the *Legenda Maior*, in which the theologian says that the account "of the admirable apparitions and prodigious works, which shone after the saint's death," serves "to dissipate every cloud of doubt and to prove the authenticity" of the great miracle, the stigmata.

Thus the first "proof" consists in a flashback to the vision had by the pope who had then canonized Francis (the same Gregory IX who originally dominated the preceding fresco) when the question still needed to be decided. It should be remembered that the rite of canonization had been definitively reserved to the Roman pontiff only a half century earlier than the execution of the frescoes—the decision dates from the time of Innocent IV (1243–1254)—, and that the papal uncertainty to which this fresco makes reference was thus particularly dramatic for contemporaries.

The pope's doubts concerned just one particular: the wound in the side. But one night, as Gregory IX was sleeping, "blessed Francis appeared to him in a dream and, with a rather severe face, reproved him for these hesitations. Then, raising his right arm high, he uncovered the wound and asked Gregory for a vial, in order to collect the gushing blood that flowed from the side. The supreme pontiff, in the vision, handed him the vial that was requested and saw it fill to the brim with living blood."

Giotto illustrates each detail: the pope asleep in a sumptuous chamber, with four counselors at the foot of the bed keeping watch; Francis, who, next to the pope, uncovers his side with his right hand, while with his left he offers the filled vial to Gregory

IX. Quite marvelous are the coffered ceiling and the complex support mechanism of the canopy over the bed.

Let us note that on the opposite side of the basilica, in this same bay is *The Dream of Innocent III*, with another pope who sees the saint in a dream. And directly across from *The Apparition to Gregory IX* is *The Prayer in San Damiano* with young Francis in prayer before the crucifix. In the chapter of *De miraculis* that precedes the account of the apparition to Gregory IX, Bonaventure—speaking about the stigmata—says that "from the time [Francis] became a soldier of the Crucified Lord, the mystery of the Cross surrounded him with its glow."[34] With the frontal juxtaposition of these two scenes, Giotto begins to conclude the cycle, completing the meaning concealed in Francis's beginnings.

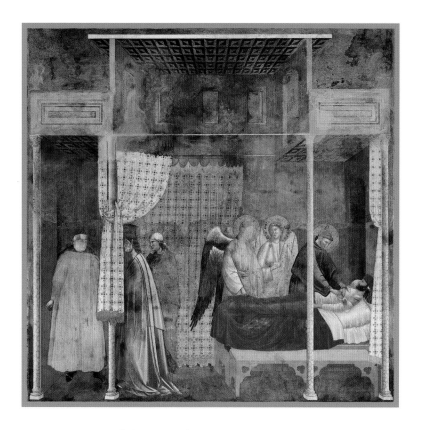

THE INSTANT HEALING OF A MAN DEVOTED TO THE SAINT

———•———

As soon as blessed Francis loosened the bandages with his hands and gently touched the wounds, John of Ylerda was perfectly healed; he had been mortally wounded and had been given up for dead by the doctors, but he had devoutly invoked Francis at the time of the injury.
—DE MIRACULIS I,5

The second miracle takes us far from Italy: to Catalonia, near Lerida, where a man named John had been struck by an assassin's sword. Bonaventure furnishes the terrifying medical report: "There was no longer absolutely any hope of saving him. In fact, the first blow had almost completely detached a shoulder and the arm, and a second had opened in his breast such a gash that the air rushing out of it could have extinguished six candles all together. In the judgment of the doctors, nothing could be done for him. . . ."

The reading of the scene in fact begins with the doctor, on the left, who with a negative gesture indicates to the man's wife and to a servant the impossibility of a cure. In fact the doctor has already left the room of the wounded man. But on the other side, beside John's bed, three other figures counterbalance the three on the left: two angels and Saint Francis, who with his right hand touches the gash in the dying man's chest. Bonaventure assures us that John was devoted to Francis, and that from his bed of suffering had never ceased to implore the saint's help.

He then saw approaching him "a man, dressed as a Friar Minor; it seemed as if he had entered through the window." This "friar" said: "Since you have confidence in me, behold: the Lord will bring about your healing," and to John's question, "Who are you?", he replied that he was Francis. The saint then "quickly approached him, untied the bandages that covered the wound, and spread an ointment (as it appeared) on all the wounds. At the gentle touch of those hands that bore the stigmata, and that from the Savior had received the power to make well, John of Lerida's flesh was restored. The gangrene disappeared and the wounds closed up, leaving the wounded man completely healthy, just as he had been before."

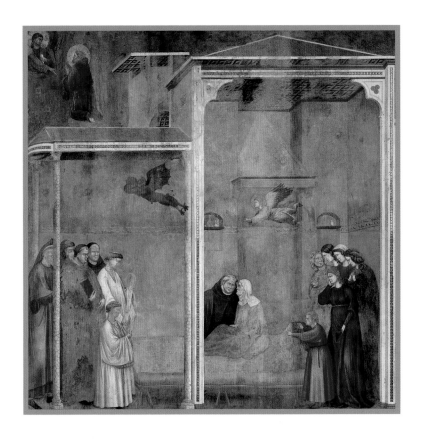

THE CONFESSION OF
A WOMAN RAISED FROM
THE DEAD

*Blessed Francis raised this dead woman, who—in the
presence of the clergy and others—made her confession of
a sin that she had never yet confessed, and then died again,
falling asleep in the Lord; and the devil fled, confounded.*
—DE MIRACULIS II,1

Bonaventure opens the account of this miracle describing a situation for which normally there is neither remedy nor cure: "In the town of Monte Marano, near Benevento, there had died a woman who was particularly devoted to Saint Francis. That evening the clerics came for her funeral service, and were preparing to celebrate the vigil with the reciting of psalms."

Unexpectedly, however, in the presence of all, the dead woman sat up on her bed and called one of the priests "who was her godfather," telling him, "Father, I want to make my confession: listen to my sin. When I died, I should have been thrown into a horrendous prison, because I had not confessed the sin that I am about to tell you. But Saint Francis prayed for me—Francis whom I always served with devotion when I was alive—, and thus I have been allowed to return to my body now, in order to confess that sin and earn eternal life. After I have confessed it, behold, I will hasten to the promised peace."

The fresco narrates the event with great clarity, beginning with the clergy gathered for the funeral service, on the left. In the center we see the woman who confesses her sin in the ear of the priest while, on the right, the other women of the house, amazed and moved, look on and comment. With the women, a child, perhaps the grandson of the "dead woman," makes as if he wants to run to her and embrace her.

But Giotto adds two particulars that Bonaventure did not mention: above the dead woman's bed he shows an angel who is chasing away a demon—an allusion, this, to the defeat of the Evil One, who would have wanted to lock the woman in that "horrendous prison" that she herself spoke of. Then, in the upper

left, the artist visualizes the meaning of the woman's assertion that "Saint Francis prayed for me," showing the Poor Little Man on his knees before Christ, who extends his right hand to him. In the preceding miracle too the credit was attributed directly to Christ, in the words addressed by the saint to the unfortunate John, "Since you have confidence in me, see, *the Lord will bring about your healing.*" In this way the image makes it clear that, notwithstanding all the power with which he has been endowed, Francis remains for all eternity the servant of Christ.

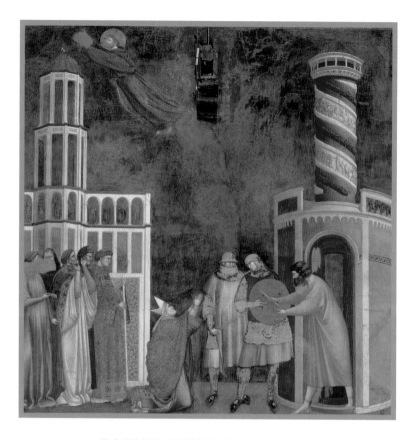

SCENE TWENTY-EIGHT

THE FREEING OF THE REPENTANT HERETIC

*Blessed Francis freed this prisoner, accused of heresy and
entrusted by papal mandate to the Bishop of Tivoli;
this occurred on the feast of blessed Francis himself,
upon whose vigil the same prisoner had fasted,
according to the custom of the Church.*
—DE MIRACULIS V,4

The last scene of the pictorial cycle recounts a miracle of theological orthodoxy: the freeing of a certain Peter of Alife, accused of heresy and imprisoned in Rome. The feast of Saint Francis was approaching, and the heretic, who was devoted to Francis, invoked him. Then, "since [Peter of Alife] had returned to sincere faith, renouncing all error and all evil heresy, and had wholeheartedly placed his trust in Francis, the champion of the Christian faith, he deserved to have his prayer heard by the Lord through the saint's intercession." Thus the evening before Francis's feast day—on the evening of October 3, that is—, "as night fell, blessed Francis went down into the prison in pity, and, calling Peter by name, commanded him to get up quickly." Peter then saw the shackles fall in pieces from his feet and the doors of the prison miraculously open. Frightened to death, instead of running away he began to scream. Then the bishop of Tivoli, to whom the prisoner had been entrusted, came and, "recognizing the fully visible presence of God's power, kneeled to worship the Lord."

The fresco illustrates these events against the backdrop of well known Roman monuments: Trajan's column, on the right, and on the left the *Septizonium* of Septimius Severus, in front of which stand clerics belonging to the bishop of Tivoli's retinue. They are amazed by the miracle, in part because it is so much like another miraculous liberation from prison, that of Saint Peter narrated in the Acts of the Apostles (12:7). Finally, in the upper left, right beside the beam that originally divided the nave from the presbytery (and which was supported by the bracket still visible today), Francis returns to heaven.

"Champion of the Christian faith," whom Honorius II had defended from the suspicion of heresy as early as 1218, with the papal bull *Cum dilecti*, Francis ascends to heaven right across from the fresco portraying his first step in the faith when, while still a boy, he accepted to walk on the mantle spread out by a simple man who foretold his glory.

In Francis as recounted by Giotto it is clear in fact that God keeps his promises.

PHOTOGRAPHY CREDITS

FIGURES FROM THE INTRODUCTION

1. Mariani / Iberfoto/Alinari Archives
2. Franco Cosimo Panini Editore © Management Fratelli Alinari
3. cod. 49672 MONDADORI PORTFOLIO / Electa / Antonio Quattrone
4. Raffaello Bencini/Alinari Archives, Florence
5. Raffaello Bencini/Alinari Archives, Florence
6. cod. akg_00293229 MONDADORI PORTFOLIO/AKG Images
7. © 2015, Foto Scala, Firenze - su concessione Ministero Beni e Attività Culturali
8. © 2015, Foto Scala, Firenze - su concessione Ministero Beni e Attività Culturali
9. © 2015, Foto Scala, Firenze
10. Franco Cosimo Panini Editore © Management Fratelli Alinari

FRESCOES IN THE BASILICA OF ASSISI

1. Franco Cosimo Panini Editore © Management Fratelli Alinari
2. Franco Cosimo Panini Editore © Management Fratelli Alinari
3. Franco Cosimo Panini Editore © Management Fratelli Alinari
4. Franco Cosimo Panini Editore © Management Fratelli Alinari
5. Alinari Archives, Florence
6. Franco Cosimo Panini Editore © Management Fratelli Alinari
7. Franco Cosimo Panini Editore © Management Fratelli Alinari
8. Franco Cosimo Panini Editore © Management Fratelli Alinari
9. Franco Cosimo Panini Editore © Management Fratelli Alinari
10. Franco Cosimo Panini Editore © Management Fratelli Alinari

11. Franco Cosimo Panini Editore © Management Fratelli Alinari

12. Franco Cosimo Panini Editore © Management Fratelli Alinari

13. Franco Cosimo Panini Editore © Management Fratelli Alinari

14. Alinari Archives, Florence

15. Alinari Archives, Florence

16. Franco Cosimo Panini Editore © Management Fratelli Alinari

17. Franco Cosimo Panini Editore © Management Fratelli Alinari

18. Franco Cosimo Panini Editore © Management Fratelli Alinari

19. Franco Cosimo Panini Editore © Management Fratelli Alinari

20. Franco Cosimo Panini Editore © Management Fratelli Alinari

21. Alinari Archives, Florence

22. Alinari Archives, Florence

23. Alinari Archives, Florence

24. Alinari Archives, Florence

25. Franco Cosimo Panini Editore © Management Fratelli Alinari

26. Franco Cosimo Panini Editore © Management Fratelli Alinari

27. Franco Cosimo Panini Editore © Management Fratelli Alinari

28. Alinari Archives, Florence

NOTES

1 The transcriptions of the Latin texts of the descriptive headings are taken from G. Ruf, *S. Francesco e S. Bonaventura. Un'interpretazione storico-salvifica degli affreschi della navata nella chiesa superiore di san Francesco in Assisi alla luce della teologia di san Bonaventura*. Assisi, 1974.

2 See *Fonti francescani*, editio minor (=FF), ed. E. Caroli et al., Assisi 1986, 511–646. Linked with the *Legenda Maior* (=LM) is Bonaventure's treatise in ten chapters on Francis's miracles, *De miraculis*, ibid., 647–692.

3 LM, prologue, 4. Cf. FF, p. 517.

4 I have described this development in greater detail in T. Verdon et al., *Arte cristiana in Italia*, 3 vol., Milan 2005–2008, I, 311–353.

5 "*Culli suoi segni remanisti, tanto el portasti in core*". This quotation is taken from the first "lauda cortonese," "Laudar vollio per amore," lines 49–50. Cf. V. Moletta, *From St. Francis to Giotto: The Influence of St. Francis on Early Italian Art and Literature*, Chicago 1983, 34. Cf. also: *Laude cortonesi dal secolo XIII al XV*, eds. G. Varanini, L. Banfi, A. Ceruti Bugio, 3 vol., Firenze 1981.

6 Concerning sacred medieval theatre, see T. Verdon, *Vedere il mistero. Il genio artistico della liturgia cattolica*, Milano 2003, especially 108–135; also see Verdon, *L'arte sacra in Italia. L'immaginazione religiosa dal paleocristiano al postmoderno*, Milano 2001, 76–89.

7 See T. Verdon, *La Basilica di San Pietro. I papi e gli artisti*, Milano 2005, 50–55.

8 LM, prologue, 4. Cf. FF, 517.

9 G. Vasari, *Vita di Giotto*, in *Le opere di Giorgio Vasari, con annotazioni e commenti di Gaetano Milanesi*, ed. P. Barocchi, Firenze 1981 (facsimile edition of the original from 1906), I, 377.

10 It is outside the scope of the present text to retrace the complexity of this debate. See the articulate discussion of the Assisi cycle in G. Previtale, *Giotto e la sua bottega*, Milano 2000 (but originally published in 1974), 55–73. Particularly rich is the bibliography given by Previali on pp. 157–168. Also see: R. Offner, "Giotto, non-Giotto I" and "Giotto, non-Giotto II," *The Burlington Magazine* (74) 1939, pp. 259–68, and (75) 1939, pp. 96–113.

11 LM, prologue, 4. Cf. FF, 516.

12 The Basilica of Saint Francis in Assisi, like the Vatican Basilica, has the presbytery on the west end, and the facade on the east end.

13 The cross was by Giunta Pisano. See Ruf, *S. Francesco e S. Bonaventura*, 15.

14 Thomas of Celano notes the parallelism with St. Martin of Tours: see *Vita seconda* (=2 Cel), 5. Cf. FF, 331.

15 Medieval scholars would have been familiar with the Vulgate use of the term *disrobe* to refer to Christ's "emptying himself," *Semetipsum exinanivit formam servi acciepiens, in similitudinem hominum factus, et habitus inventus ut homo.*

16 Thomas of Celano, *Vita prima* (1 Cel), 3. See FF, 203–204.

17 LM, IV,3. See FF, 542.

18 *Legenda perugina* (=LP), 23. See FF, 770.

19 2 Cel. 416. See FF, 416.

20 LP 81. See FF, 828–829.

21 Ibid.

22 1 Cel. 84–87. See FF, 267–270.

23 Ibid.

24 Ibid.

25 LM VII, 13. See FF, 580.

26 G. Vasari, *Vita di Giotto* (see note 9).

27 See FF, 136.

28 1 Cel. 58. See FF, 249.

29 LM XI, 3. See FF, 608.

30 LM XIII, 4. See FF, 629.

31 LM XV, 2. See FF, 642.

32 Cel. 124–125. See FF, 304–306.

33 1 Cel. 126. See FF, 306–307.

34 *De miraculis* I, 1. See FF, 647.

ABOUT PARACLETE PRESS

WHO WE ARE

As the publishing arm of the Community of Jesus, Paraclete Press presents a full expression of Christian belief and practice—from Catholic to Evangelical, from Protestant to Orthodox, reflecting the ecumenical charism of the Community and its dedication to sacred music, the fine arts, and the written word. We publish books, recordings, sheet music, and video/DVDs that nourish the vibrant life of the church and its people.

WHAT WE ARE DOING

Books

PARACLETE PRESS BOOKS show the richness and depth of what it means to be Christian. While Benedictine spirituality is at the heart of who we are and all that we do, our books reflect the Christian experience across many cultures, time periods, and houses of worship.

We have many series, including *Paraclete Essentials*; *Paraclete Fiction*; *Paraclete Poetry*; *Paraclete Giants*; and for children and adults, *All God's Creatures*, books about animals and faith; and *San Damiano Books*, focusing on Franciscan spirituality. Others include *Voices from the Monastery* (men and women monastics writing about living a spiritual life today), *Active Prayer*, and new for young readers: *The Pope's Cat*. We also specialize in gift books for children on the occasions of Baptism and First Communion, as well as other important times in a child's life, and books that bring creativity and liveliness to any adult spiritual life.

The MOUNT TABOR BOOKS series focuses on the arts and literature as well as liturgical worship and spirituality; it was created in conjunction with the Mount Tabor Ecumenical Centre for Art and Spirituality in Barga, Italy.

Music

The PARACLETE RECORDINGS label represents the internationally acclaimed choir *Gloriæ Dei Cantores*, the *Gloriæ Dei Cantores Schola*, and the other instrumental artists of the *Arts Empowering Life Foundation*.

Paraclete Press is the exclusive North American distributor for the Gregorian chant recordings from St. Peter's Abbey in Solesmes, France. Paraclete also carries all of the Solesmes chant publications for Mass and the Divine Office, as well as their academic research publications.

In addition, PARACLETE PRESS SHEET MUSIC publishes the work of today's finest composers of sacred choral music, annually reviewing over 1,000 works and releasing between 40 and 60 works for both choir and organ.

Video

Our video/DVDs offer spiritual help, healing, and biblical guidance for a broad range of life issues including grief and loss, marriage, forgiveness, facing death, understanding suicide, bullying, addictions, Alzheimer's, and Christian formation.

Learn more about us at our website
www.paracletepress.com
In the USA phone us toll-free at 1.800.451.5006;
outside the USA phone us at +1.508.255.4685

SCAN
TO
READ
MORE

ALSO AVAILABLE FROM MOUNT TABOR BOOKS AT PARACLETE PRESS

THE ECUMENISM OF BEAUTY

Edited by Timothy Verdon

ISBN 978-1-61261-924-8 | $28.99, Hardcover

FAIR JESUS

The Gospels According to Italian Painters 1300–1650

Robert Kiely

ISBN 978-1-64060-258-8 | $39.99, Hardcover

ART & PRAYER

The Beauty of Turning to God

Timothy Verdon

ISBN: 978-1-64060-423-0 | $29.99, Trade paperback

Available at bookstores
Paraclete Press | 1-800-451-5006
For the complete Mount Tabor Collection visit www.paracletepress.com

Mount Tabor Books focuses on the arts and literature as well as liturgical worship and spirituality, and was created in conjunction with the Mount Tabor Ecumenical Centre for Art and Spirituality in Barga, Italy. Learn more at www.mounttabor.it.